Ethiopian Passages

Contemporary Art from the Diaspora

Elizabeth Harney

with contributions by

JEFF DONALDSON
ACHAMYELEH DEBELA
KINSEY KATCHKA

Smithsonian
National Museum of African Art

Philip Wilson Publishers

COVER
Mickaël Bethe-Selassié
Voyage Initiatique (plate 27)
Collection of the artist

BACK COVER
Aida Muluneh
Spirit of Sisterhood (plate 20)
Collection of the artist

PAGE 16
Etiyé Dimma Poulsen
Grouping of the sculptures *Untitled II, Homme carré,*
Untitled III and *Femme au carré rouge* (left to right)
Collection of the artist

PAGE 98
Alexander "Skunder" Boghossian
Time Cycle III (detail, plate 11)
Contemporary African Art Gallery, New York

PAGE 114
Elizabeth Habte Wold
Lonely Mother (detail, plate 7)

Published in conjunction with the exhibition *Ethiopian Passages:*
Dialogues in the Diaspora, organized by the National Museum of
African Art, Smithsonian Institute, May 2 – October 5, 2003.

Cataloging-in-Publication Data is available from the Library of Congress

ISBN 0 85667 562 8

Edited by Migs Grove
Designed by Peter Ling
Printed in Italy by EBS of Verona
The text is printed on 150 gms matt coated cartridge
∞ The paper used in this publication meets the requirements of the
American National Standard for Information
Sciences—Permanence of Paper for Printed Library Materials ANSI
Z39.48-1984

First published by Philip Wilson Publishers,
7 Deane House, 27 Greenwood Place, London NW5 1LB
Distributed in the United States and Canada by Palgrave Macmillan,
175 Fifth Avenue, New York, NY 10010
Distributed in the UK and the rest of the world by I.B. Tauris & Co. Ltd,
6 Salem Road, London W2 4BU

PHOTO CREDITS
National Museum of African Art/Franko Khoury: plates 4–18,
21–23, 25–30; figs. 9, 11, 14–21; pp. 16, 98, 102, 114
Courtesy The Project, New York: frontispiece, plates 1–3, fig. 7,
p. 56 (artist's photo)
Courtesy Kebedech Tekleab: fig. 8, pp. 60, 68 (artist's photo)
Courtesy Elizabeth Habte Wold: fig. 10, p. 64 (artist's photo)
Courtesy Meskerem Assegued: p. 72 (artist's photo)
David A. Binkley: pp. 76, 88 (artists' photos)
Courtesy Aida Muluneh: plates 19–20, p. 80 (artist's photo)
Courtesy Wosene Kosrof: plates 24, p. 84 (artist's photo)
Courtesy Achamyeleh Debela: figs. 22–25, p. 92 (artist's photo)

Contents

Foreword

In the global arena, African artists have contributed significantly to the inventiveness and creative vitality of the contemporary art world. This impact has been more immediate and pronounced for Western audiences as African artists move into the growing and significant diaspora in America and Europe. *Ethiopian Passages: Dialogues in the Diaspora* introduces audiences to the importance of the arts of the African diaspora and seeks to familiarize audiences with the important histories of migration and the myriad negotiations of artistic, cultural, group and personal identities among African artists in the diaspora. As Elizabeth Harney notes in her essay, *Ethiopian Passages* is not intended to be "comprehensive in scope. . . . what it does claim is an intention and desire to sketch, in broad strokes, the complexities, diversity and vibrancy of artistic practices among artists of Ethiopian descent at work today." In doing so, it brings together artists, from across several generations, who have addressed issues of identity, experienced displacement and created new senses of home. The evidence of these encounters and personal experiences, often traced subtly across the surfaces of works of art, reaffirms our belief in the magnificence of contemporary African art and its arresting power.

The National Museum of African Art has been a pioneer in the acquisition and display of modern and contemporary African art for more than 25 years. In 1974 the museum, then a private educational institution located on Capitol Hill, mounted *Contemporary African Art,* one of the first exhibitions of its kind in the nation. Since opening its doors on the National Mall in 1987, the museum has held 15 contemporary art exhibitions, including *Mohammad Omer Khalil, etchings and Amir Nour, sculpture* (1994), *The Poetics of Line: Seven Artists of the Nsukka Group* (1997), *Claiming Art/Reclaiming Space: Post-Apartheid Art from South Africa* (1999), *A Concrete Vision: Oshogbo Arts in the 1960s* (2000) and *Encounters with the Contemporary* (2001).

African Art's contemporary collection began with the donations of works by, most notably, Bruce Onobrakpeya, Valente Malangatana Nwengya, Twins Seven-Seven and El Salahi. The collection has grown through the interests and efforts of museum directors Sylvia Williams and Roslyn Adele Walker, associate director Roy Sieber, chief curator Philip Ravenhill and curator Elizabeth Harney. With the establishment of a permanent curatorial position for contemporary art, the museum has reinforced its commitment to collecting and exhibiting contemporary African art. The collection now includes 72 works by important and influential

artists from the expanding African diaspora—among them, Mickaël Bethe-Selassié, Alexander "Skunder" Boghossian, Sokari Douglas Camp, Mohammad Omar Khalil, Wosene Kosrof, Amir Nour, Magdalene Odundo, Etiyé Dimma Poulsen, Gerard Sekoto, Yinka Shonibare and Ouattara Watts.

The museum currently is the only arts institution in this country with: a clear mandate to collect, display, publish and educate audiences about contemporary African arts; a curatorial position dedicated to its study; gallery space reserved for its presentation; and a number of exciting projects under development. The contemporary arts collection and programs operate in consort with the museum's strong commitment to Africa's tradition-based arts, thus enabling audiences to understand the complex dialogue between these artistic practices.

As Harney suggests, the National Museum of African Art is clearly aware of the tensions between the mandate to collect and exhibit contemporary African art and its tendency to demarcate or even ghettoize the very artists we wish to support in an institution that is wholly focused on the African continent. Many artists on the continent and those who are part of the diaspora wish to circumvent any attempt to marginalize them and categorize their art into a particular geographical location, school, period or movement. The tremendous variety of artistic expressions across a number of generations would certainly preclude any such categorization. It is the challenge of the museum to remain relevant to a broad range of artists and practices as it supports exhibitions and publications that further the growth and development of the contemporary collection.

David A. Binkley
Chief Curator
National Museum of African Art

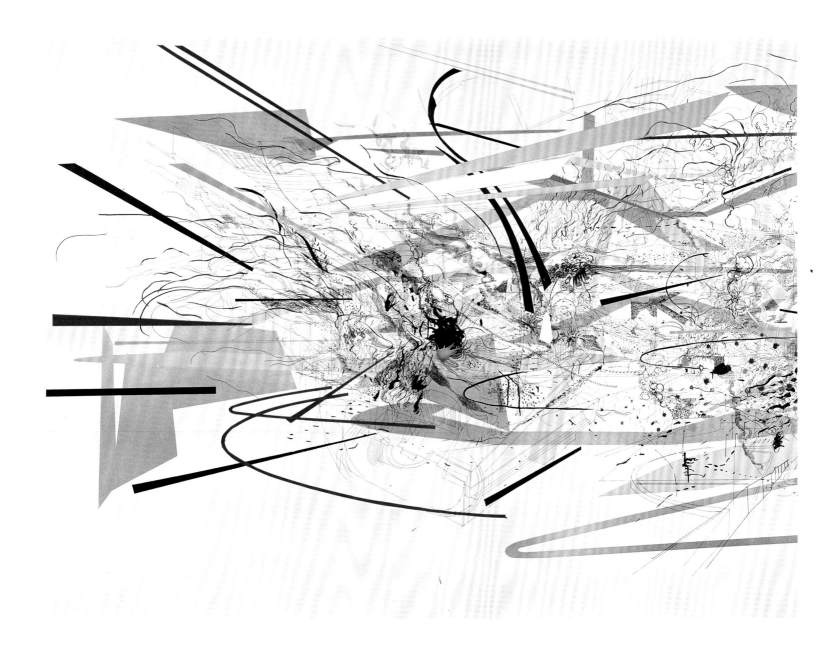

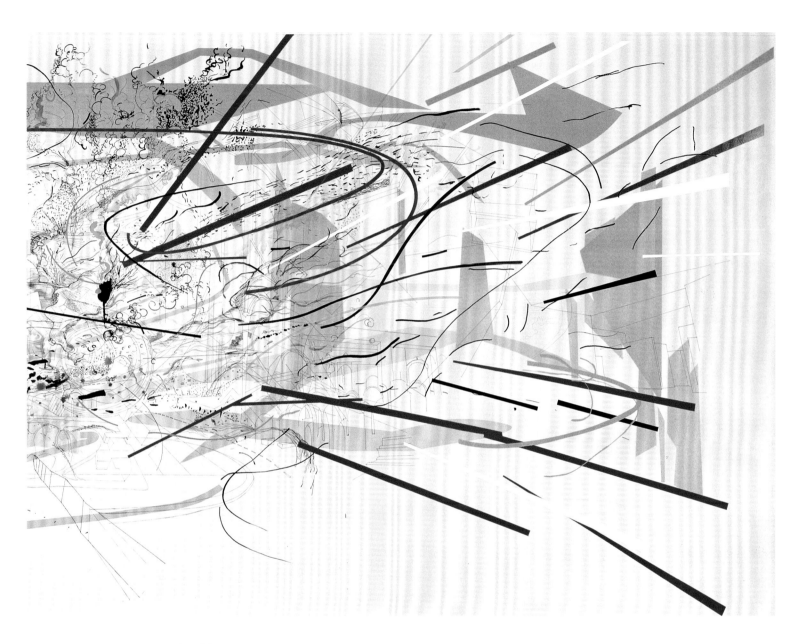

JULIE MEHRETU
Untitled
2001
Ink and acrylic on canvas
Each panel: 18.3 x 24.4 m (6 x 8 ft)
Courtesy of The Project, New York

Preface

Since the 1970s, a number of small exhibitions and publications have highlighted the arts of the Ethiopian diaspora. In 1973, the modest exhibition *Ethiopian Artists in America* featured the works of eight male artists of the first generation to emigrate from Ethiopia.[1] Four years later, *African Artists in America,* an exhibition sponsored by the African-American Institute in New York, featured the works of Achamyeleh Debela, Skunder Boghossian and Tesfaye Tessema—three artists from Ethiopia.[2]

Jean Kennedy's posthumous publication, *New Currents, Ancient Rivers*, contained a section on the arts of Ethiopia that focused primarily on the works of pioneers in African modernism such as Skunder Boghossian, Afewerk Tekle and Gebre Kristos Desta.[3] Unfortunately, this important publication was never accompanied by an exhibition. Both Evelyn Brown's and Ulli Beier's publications about contemporary arts in Africa turned our attention to the pioneering modernists (1966 and 1968 respectively).[4] Over the last several decades there have also been a number of articles in Ethiopian, African and African-American journals on the works of Skunder and others working in the 1950s and 1960s.

Three noteworthy exhibitions in the last few years addressed the works of contemporary Ethiopian artists; however, none used the lens of diaspora as their framework. The first, and perhaps best known, was the "Addis Connections" segment in *Seven Stories about Modern Art in Africa* (London 1995).[5] The narrative provided a useful overview of the art school in Addis Ababa and a look at important artistic manifestos that emerged through this first generation. Nevertheless, as part of a much larger exhibition, it could do little but suggest the possibilities of scholarship. The second was a small show organized by Salah Hassan entitled *Gendered Visions* (Cornell University 1997) that looked at the works of selected African and African-American female artists.[6] The works of sculptor/ceramicist Etiyé Dimma Poulsen and mixed media artist Elisabeth Atnafu, who are included in *Ethopian Passages*, were both featured therein.

Finally, an important catalogue and exhibition produced by Elisabeth Biasio at the Ethnological Museum at the University of Zurich entitled *The Hidden Reality: Three Contemporary Ethiopian Artists* provided thorough and in-depth discussions of the history of modern and contemporary Ethiopian arts practice.[7] Perhaps as significant were her portraits of the oeuvres of Worku Goshu, Girmay Hiwet (in the diaspora) and Zerihun Yetmgeta, a key figure in the arts scene in Addis Ababa.

In the last decade of the last century, curators and critics began to focus more critically on the space of diaspora as an important terrain of artistic practice. Exhibitions such as *Transforming the Crown*, which looked at the arts of black British artists, and *Cross/ing: time, space, movement*, which brought together the works of expatriate Africans in Europe and the United States, asked "how the conditions of exile and expatriation provide new motifs and challenges to the new discourse of Africa in the late twentieth century."[8]

These exhibitions strove to present "the work of African artists who, though no longer bound by the old affiliations of geography and race, inevitably reflect [on] their common claim to Africa in their work."[9] Furthermore, the exhibition and scholarly publication for *The Short Century: Independence and Liberation Movements in Africa, 1945–1994* provided a much-needed, broad overview of the critical coalescence of anti-colonialist, pro-Independence, pan-Africanist histories of the continent within which artists played key roles.[10] It is upon the examples of these curatorial forays that this exhibition draws.

Ethiopian Passages: Dialogues in the Diaspora brings together the works of 10 artists of Ethiopian descent living in a diaspora that stretches from Ethiopia to California, New York, Washington, D.C. and France. Their creative approaches, chosen media, artistic narratives and personal histories are eclectic, but they all share an attachment to Ethiopia and experiences of dislocation. Perhaps more than any other group of African peoples in the last part of the 20th century, Ethiopians embarked on journeys, both near and far, fleeing intolerable circumstances at home and often joining a network of family and friends in other parts of the globe.

This modest exhibition could never be comprehensive in scope. It will not include pieces by a number of talented artists long at work in the diaspora. What it does claim is an intention and desire to sketch, in broad strokes, the complexities, diversity and vibrancy of artistic practice amongst artists of Ethiopian descent at work today. It thus brings together established individuals—for example, Skunder Boghossian and Mickaël Bethe-Selassié, whose large bodies of work are clearly deserving of retrospectives—with young, emerging artists such as Julie Mehretu and Etiyé Dimma Poulsen whose brilliant aesthetic sensibilities rivet the attention of all who engage with their works and hold the promise of long and successful careers.

Ethiopian Passages is an important undertaking at the National Museum of African Art, especially as the museum continues to collect and shape its holdings of contemporary arts. This exhibition represents our first large-scale effort to introduce audiences to the significance and richness of the arts of African diaspora contemporary artists and, in the process, it also challenges the parameters of our mission.

Charged with presenting the arts of the African continent from ancient to contemporary times, the museum is obliged to question the shifting definitional borders of the field. Where exactly does Africa begin and end? How does the museum begin to define "Africa" for the purposes of collection, categorization and display without perpetuating stale, essentialist and pernicious claims to authenticity or pure, bounded and timeless cultures?

In order for an institution to remain relevant it must be able to adapt to the realities of the global art world. While the museum has been at the forefront of collecting and exhibiting contemporary artworks, this practice has not come easily. It exists in tension with the ongoing

strengths of the museum's tradition-based collection. The presence of contemporary materials within the museum's walls calls into question the conventional methods of display for traditional African arts, which inevitably appear linked to a bygone era.

Perhaps more important, however, are the challenges that this exhibition brings to definitions of authenticity that govern the market for tradition-based works—a market that is essentially limited to the circulation of masterpieces in and out of private and public collections in the West. Unlike unnamed creators of most tradition-based works, contemporary African artists participate in the discourse surrounding their works, seeking, as opportunity arises, to control the context in which their works are shown and critiqued. Some may not wish to see their works limited to a space that uses the lens of identity as a measure for inclusion and debates of authenticity must now incorporate the perspectives of artists.

It would seem then that the very mission of an identity-based institution is under scrutiny in this age of transnationalism and global arts. It is against this backdrop of concerns that the museum mounts this exhibition, cognizant of the sensitive and shifting territory in which it operates. As Olu Oguibe has noted:

Africa is no longer the landmass between continents: it has become a referent for many who reside within multiple other borders, those who carry the continent but not the landmass with them.[11]

As we continue our mission to collect contemporary African arts, it seems clear that the institutional terrain of the international art world has not, as yet, shifted significantly in favor of Africa's artists. They are, for the most part, still locked out of the galleries and storerooms of our sister modern and contemporary arts institutions. Even as the marketplace claims greater sensitivity towards a more global understanding and appreciation of the contemporary, Africa's artists remain oddly absent and therefore silent and invisible.

While many curators have preferred to focus on the individual nature of diasporic practice, emphasizing the performative and negotiated nature of identity in relation to the visual, we have chosen to focus on the artistic creations of a select group of artists.

By focusing on one group of individuals who are perceived as belonging to a recognizable immigrant community and to a distinctive set of "homelands" (Ethiopia, Eritrea, Tigray), this investigation is able to better define prevalent notions of identity and "Africanness" by acknowledging that many move beyond narrow affiliations in daily life and artistic practice. The artworks allow one to acknowledge the creative tensions between localism and worldliness. Identity, whether it be shared or individual, artistic or otherwise, should not be seen as "transparent and unproblematic" or an "already accomplished fact" but rather as something "in process" that is "always constituted within not outside of representation."[12] In presenting the works of these 10 extraordinary artists, it is our hope to consider *diaspora* as an exploratory rather than simply an explanatory term.[13]

Elizabeth Harney
Curator, Contemporary Arts

ENDNOTES

1 *Ethiopian Artists in America* (Washington D.C.: Office of African-American Affairs and the Arts and Humanities Program, 1973).

2 *African Artists in America: An Exhibition of Work by Twenty African Artists Living in America* (New York: African-American Institute, 1977).

3 Jean Kennedy, *New Currents, Ancient Rivers: Contemporary African Artists in a Generation of Change* (Washington, D.C.: Smithsonian Institution Press, 1992).

4 Evelyn S. Brown, *Africa's Contemporary Art and Artists* (New York: Harmon Foundation, 1966); Ulli Beier, *Contemporary Art in Africa* (London: Pall Mall, 1968).

5 Clementine Deliss, *Seven Stories about Modern Art in Africa* (London: Whitechapel Gallery, 1995).

6 Salah Hassan ed., *Gendered Visions: The Art of Contemporary Africana Women Artists* (Trenton, N.J.: African World Press, 1997).

7 Elisabeth Biasio, *The Hidden Reality: Three Contemporary Ethiopian Artists* (Zurich: Volkerkundemuseum der Universitat, 1989).

8 Moira J. Beauchamp-Byrd and M. Franklin Sirmans, eds., *Transforming the Crown: African, Asian, and Caribbean Artists in Britain 1966–1996* (New York: The Franklin H. Williams Caribbean Cultural Center/Africa Diaspora Institute, 1997); Olu Oguibe, *Cross/ing: time, space, movement* (Santa Monica, Calif.: Smart Press, 1998), 59.

9 Olu Oguibe, *Cross/ing: time, space, movement*, 13.

10 Okwui Enwezor, ed., *The Short Century: Liberation and Independence Movements in Africa, 1945–1994* (Munich, London, New York: Prestel, 2001).

11 Ibid., 12.

12 Stuart Hall,"New Ethnicities" in *ICA Documents 7: Black Film, British Cinema*, ed. Kobena Mercer, (London: Institute of Contemporary Arts, 1989).

13 Sarat Maharaj, "Semi-Semitic Serependitist 'you' Europeanised Afferyank." Abstract for conference accompanying the first Johannesburg Art Biennale, 1995.

In Ethiopia it is customary to refer to an individual by his or her given first name. To use one's surname is to refer to an individual's father, not the individual. Following Ethiopian convention, the artists herein are, where appropriate, referred to by their first names.

Acknowledgments

Developing the exhibition *Ethiopian Passages: Dialogues in the Diaspora* was, at once, challenging and extremely rewarding. I have to thank, first and foremost, the 10 talented artists who have been generous with their time and supportive of the museum's efforts in countless ways. They share in the success of this undertaking. As the study of contemporary African arts continues to grow, exhibition and publication opportunities are paramount in securing a place for these creative artists within the broader art history of the 20th and 21st centuries. Ultimately the catalogue *Ethiopian Passages: Contemporary Art from the Diaspora* documents not only the exhibition but, more importantly, significant works of art.

Many have contributed to the completion of the Ethiopian Passages project. I'd like to thank Jeff Donaldson for his contributions, both written and verbal, to the conceptualization. His understanding of the complexities and subtleties of diaspora in relation to the visual arts was invaluable. Furthermore, the support of his Howard colleagues, Abiyi Ford and Floyd Coleman resulted in a stronger, broader understanding of the topography of diaspora history in the Howard University arts community and beyond. To Carol Dyson, thank you for interviewing the artists who attended Howard University and for researching information about Howard's programs.

Achamyeleh Debela's contributions enabled the museum to highlight the history of the arts scene in Addis Ababa. While space, funding and time would not allow us to include more artworks from others in the diaspora or Addis Ababa, Achamyeleh's survey of the history and brief overview of the current state of affairs in the Ethiopian capital illuminates the real links between the diaspora and homeland, contemporary artmaking and history.

I first delineated the parameters of the exhibition and publication several summers ago while working with Heran Sereke-Brhan, then a graduate student at Michigan State University and Smithsonian fellow. I thank her for her enthusiasm, her introductions to numerous artists and community members and her work on the educational outreach programs. I want to thank Ed Lifshitz, curator of education, for supporting Heran's work and his efforts in bringing the exhibition to a broader public.

David Binkley is a key advocate for the contemporary arts programming at the museum and has always been a much-appreciated supporter. I thank him for his continuing belief in my abilities and infectious enthusiasm for great art.

Research associate Kinsey Katchka deserves credit for her tirelessness in helping me keep this project on track. Her suggestions about content, management of image reproduction and negotiations of all kinds between artists, museum departments and curator were all performed in good spirits, with clarity of purpose and skill.

Throughout the planning of this exhibition, the museum has been mindful that it operates amidst the largest Ethiopian diaspora community in the United States. The opportunities to build long-lasting ties to this community have been bettered through the work of a volunteer task force: Ambassador Ayalew Mandefro, Jomo Tariku, Frehiwot Haileloul, Yohanne Hapte Yesus, Alemtsehay Wedato, Abiyi Ford. I thank all its members for their generosity of time and spirit. His Excellency Kassahun Ayele, Ambassador, and the staff of the Embassy of Ethiopia and U.S. Ambassador to Ethiopia Aurelia Brazeal and her staff in Addis Ababa have also been instrumental in helping the museum find appropriate contacts within and beyond the Ethiopian community.

I'd like to thank Robert Krill, former Ambassador Irvin Hicks and Alitash Kebede, who have lent their expertise and time in the pursuit of funding. Many thanks also to the members of the museum's Board of Directors; Tom Lentz, director of the International Art Museums Division; and former director Roslyn A. Walker. The Smithsonian Scholarly Studies program also generously supported this project.

New and old friends in the gallery world gave generously of their materials and time. Thank you to Bill Karg at Contemporary African Art Gallery for lending works, images and knowledge; Melissa Montgomery at the Project Gallery, NYC, for facilitating Julie Mehretu's loans and on-site work created especially for this exhibition; and finally to Meskerem Assegued for introducing me to Elisabeth Atnafu, providing information about the arts scene in Addis Ababa and her continuing advocacy for the arts in Addis and abroad.

Numerous members of the African Art staff were integral in the realization of the exhibition and publication. I'd particularly like to thank curatorial assistant Allyson Purpura; photographer Franko Khoury; Julie Haifley and the registration department; Steve Mellor and the conservation staff; Paul Wood in the Eliot Elisofon Photographic Archives; Dale Mott and the external affairs department; the exhibits staff under the direction of Alan Knezevich; and editor Migs Grove.

Finally my thoughts and thanks go to Paul and my boys who were always ready with smiles despite living with a distracted curator.

This exhibition and publication emerge at a time of great suffering and sorrow for the peoples of Ethiopia, where famine and drought threaten the lives of more than 14 million people. It is to the victims of this terrible catastrophe that these efforts are dedicated.

Chronology

10th century B.C. Maqueda (Queen of Sheba) believed to have gone to Jerusalem and had Menelik I, son of King Solomon and founder of Solomonic dynasty.

1st–4th century A.D. Axum flourishes as city-state built on trade. King Ezana converts to Christianity.

14th–16th century Rock-hewn churches erected at Lalibela.

1530s–43 Muslim armies occupy highlands, destroy churches and manuscripts.

1607–37 Ethiopian Orthodox Church established. City of Gondar built as capital (remains capital city for 200 years).

1769 Oromo takes over power at Gondar.

1855 Reign of Emperor Tewodros II begins.

1868 Tewodros defeated by a British expeditionary force and commits suicide.

1872 Tigrayan chieftain becomes Yohannes IV.

1889 Yohannes IV killed while fighting Mahdist forces and is succeeded by the king of Shoa, who becomes Emperor Menelik II.

Menelik signs a bilateral friendship treaty with Italy, which Italy interprets as giving it a protectorate over Ethiopia.

Addis Ababa becomes Ethiopia's capital.

1895 Italy invades Ethiopia.

1896 Under Menelik II, Ethiopian forces defeat the invading Italian army at Adwa; Italy recognizes Ethiopia's independence but retains control over Eritrea.

1913 Menelik dies and is succeeded by his grandson, Lij Iyasu.

1916 Lij Iyasu deposed and is succeeded by Menelik's daughter, Zawditu, who rules through a regent, Ras Tafari Makonnen.

1922 William Leo Hansberry (1884–1965) establishes the first of four courses in African art history at Howard University, in Washington, D.C.

1928 Ralph Bunche, statesman and scholar, begins teaching at Howard University.

James Herring founds the Howard University Art Gallery.

1929 Malaku Bayen, the first Ethiopian student to study at Howard University, graduates from Howard's medical school.

1930 Zawditu dies and is succeeded by Ras Tafari Makonnen, who becomes Emperor Haile Selassie I.

1935 Italy invades Ethiopia.

1936 Italians capture Addis Ababa, Haile Selassie flees, king of Italy made emperor of Ethiopia; Ethiopia combined with Eritrea and Italian Somaliland to become Italian East Africa.

1941 British and Commonwealth troops, greatly aided by the Ethiopian resistance, defeat the Italians and restore Haile Selassie to his throne.

1952 United Nations federates Eritrea with Ethiopia.

1957 School of Fine Arts founded in Addis Ababa.

1962 Haile Selassie annexes Eritrea, which becomes an Ethiopian province.

1970 Elisabeth Atnafu becomes the first Ethiopian-born student to enroll in Howard University's Fine Arts program.

1972 Alexander "Skunder" Boghossian begins teaching at Howard University.

1973–74 An estimated 200,000 people die of famine in Wallo province.

1974 Haile Selassie deposed in coup led by Tafari Benti.

1975 Haile Selassie dies under mysterious circumstances while in custody.

Elisabeth Atnafu completes her BFA at Howard University.

1977 Tafari killed and replaced by Mengistu Haile Mariam.

1977 Somalia invades Ethiopia's Ogaden region.

1977–79 Thousands of government opponents die in "Red Terror" orchestrated by Mengistu; collectivization of agriculture begins; Tigrayan People's Liberation Front launches war for regional autonomy.

1978 Somali forces defeated with massive help from the Soviet Union and Cuba.

1980 Wosene Kosrof completes an MFA at Howard University.

1985 Worst famine in a decade strikes; Western food aid sent; thousands forcibly resettled from Eritrea and Tigray.

1987 Mengistu elected president under a new constitution.

1988 Ethiopia and Somalia sign a peace treaty. Ethiopian Peoples' Revolutionary Democratic Front (EPRDF) forms and allies with the existing Tigray People's Liberation Front.

1991 Ethiopian Peoples' Revolutionary Democratic Front, an umbrella organization of ethnic-based organizations under the control of Tigray Peoples' Liberation Front, captures Addis Ababa, forcing Mengistu to flee to Zimbabwe. Eritrea establishes its own provisional government pending a referendum on independence.

1993 Eritrea becomes independent following referendum.

Elizabeth Habte Wold completes an MFA at Howard University

1994 New constitution divides Ethiopia into ethnically based regions.

1995 Negasso Gidada becomes titular president; Meles Zenawi becomes prime minister.

Kebedech Tekleab receives an MFA from Howard University.

1998 Ethiopian-Eritrean border dispute erupts in armed clashes.

1999 Ethiopian-Eritrean border clashes turn into a full-scale war.

2000 More than eight million Ethiopians face starvation after three successive years of poor rain and failed harvests. Ethiopia and Eritrea sign a peace agreement in Algeria, formally ending two years of conflict.

2001 Ethiopia announces it has completed its troop withdrawal from Eritrea in accordance with a United Nations-sponsored agreement to end the border war.

Aida Muluneh completes a BA at Howard University.

2002 Prime Minister Meles Zenawi warns that Ethiopia faces a famine worse than that of 1984, which killed nearly one million people.

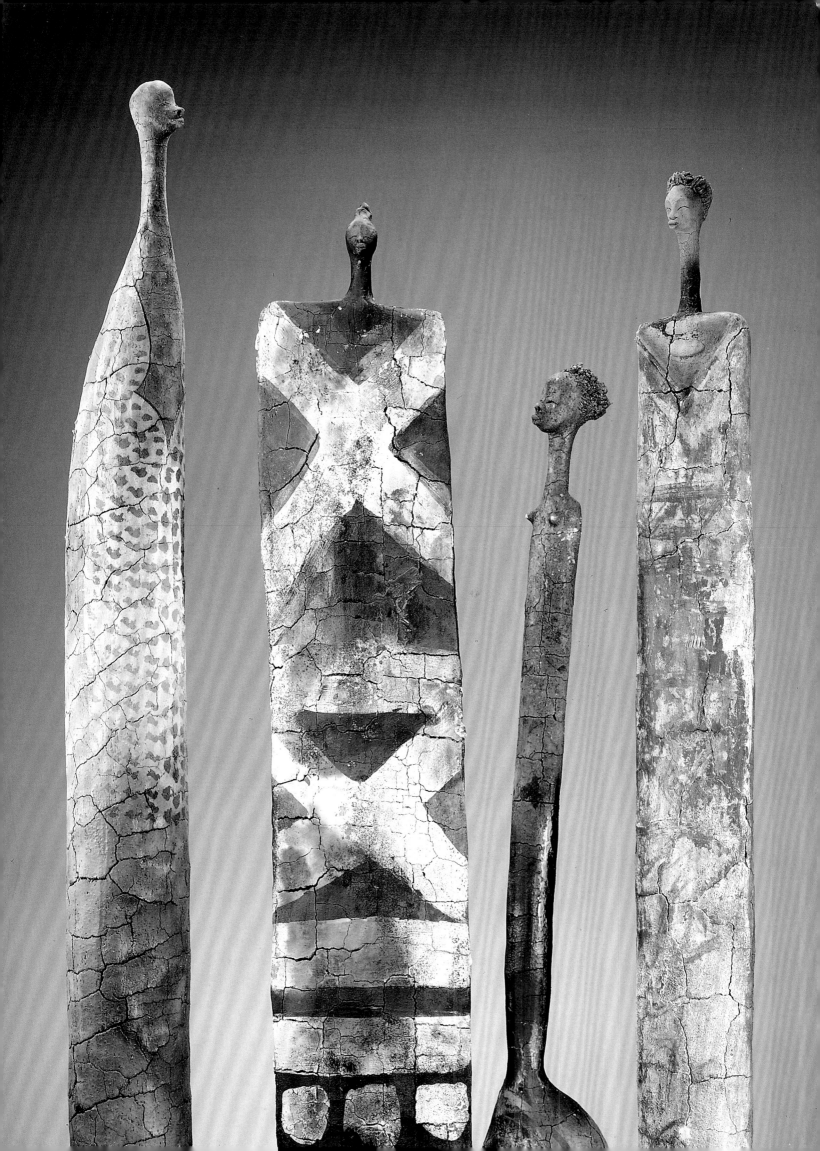

The Poetics of Diaspora

Elizabeth Harney

n his collection of essays entitled *Imaginary Homelands,* Salman Rushdie writes:

> *The effect of mass migrations has been the creation of radically new types of human beings: people who root themselves in ideas rather than in places, in memories as much as in material things, people who are obliged to define themselves—because they are so defined by others—by their otherness; people in whose deepest selves strange fusions occur, unprecedented unions between where they were and where they find themselves. The migrant suspects reality: having experienced several ways of being, he understands their illusory nature. To see things plainly, you have to cross a frontier.*[1]

This famous exile's ruminations upon one of the defining features of the 20th century—the condition of migrancy—set the frame for fruitful investigations of the linkages between diasporic experience and the making of visual arts. In an increasingly mobile society, contemporary artists who have engaged with these now common experiences help us to understand better the contours of diaspora and exile.

Over the last century, the movement, displacement and relocation of individuals from across the globe have given birth to many of the most poignant and enduring facets of global modernist arts and cultures. Certainly, the post-colonial expressions of many African artists and intellectuals are informed, in part, by their experiences of diaspora. Anti-colonial activism and the seeds of a discourse defining a shared racial and political consciousness (pan-Africanist and Négritude ideologies) were nurtured within the crucible of the diaspora. During their sojourns in the European metropoles, young students, intellectuals and future leaders of independent African and Caribbean nations and African Americans alike re-articulated their place in the world. Perhaps most importantly, they were able to imagine the possibilities of shaping a new and better world. Writings by luminaries such as Aimé Césaire, Richard Wright, Léopold Senghor and George Padmore shaped and were, in turn, fostered by an expatriate pan-African community.

Since the collapse of colonialism and the end of the Cold War, migration flows have shifted significantly. Previous geographic and cultural demarcations of center and periphery, Third and First World, and East and West no longer apply, if they ever did, and every

boundary and border is porous. The scope of these journeys has ranged from moves within a nation's borders (including migrations from rural to urban settings) to great flows across territories, cultures and time zones. In all cases, migrants are forced to reconsider and renegotiate affiliations to home, identity and community. Some move in pursuit of economic opportunity or to join family members, many others to escape the turmoil of war, famine or political, cultural, religious and gender-based oppression.

So great have been the shifts in modern society that scholars have struggled to develop appropriate paradigms and critical language with which to understand them. In the early part of the 20th century, great waves of immigrants, fleeing pogroms, economic instability and the two World Wars contributed to the peopling of North America. Their journeys were understood as a series of chain migrations, flows that led to the establishment of distinctive, bounded ethnic enclaves. Eventually, it was argued, the "foreign" ways of these émigrés would cease to exist within the great American melting pot. Traditionally, social scientists used the term *diaspora* to refer specifically to the spread of Jews, Armenians and Greeks throughout the globe.[2] Diaspora thus suggested a fanning out from a single point of cultural or national origin and included an expectation of eventual return to a home, whether it be to a real or imagined one.

Diaspora is now used by many to explore "contact zones of nations, cultures and regions; terms such as border, travel, creolization, hybridity and diaspora" are common to the greater discourse of transnationalism (Clifford 1994: 303). As James Clifford has noted in his important investigation of the paradigms of travel in contemporary cultures:

> . . . for better or worse, diaspora discourse is being widely appropriated. It is loose in the world, for reasons having to do with decolonization, increased immigration, global communications, and transport—a whole range of phenomena that encourage multi-locale attachments, dwelling, and traveling within and across nations.[3]

This renewed fascination with diaspora brings with it a whole range of elements, which serve to delineate the substance and texture of its existence. A sense of displacement and loss—nostalgia for home and a re-imagining of its realities—accompanies these movements. As noted above, the fluid and fragmented nature of an émigré's life leads also to re-articulations of identity and new understandings of belonging to place and community. This need to define a sense of "home" is an intimate part of the experience of diaspora. Although much has been made of the "nomadic" nature of today's society, perhaps less has been said about the means through which individuals relocate and establish what Homi Bhabha has called a certain "measure of dwelling."[4] The process of globalization, with all its attendant discussions of transnational capitalism, technology flows and shared consumer culture, does not eclipse the need for local cultural frameworks.

Ideas of belonging and efforts to make place out of space center around memory as a tool for imagining and capturing the features of the home left behind. Memory often serves as the inspiration for the telling of narratives, which rely most significantly upon oral histories. Not surprisingly, artists in the visual, literary, musical and theatrical realms have been at

the frontiers of exploring the depths and riches of memory, referencing traces of cultural traditions, reclaiming them as their own and mixing them with new experiences as they create collages of artistic and personal identity.

In the works of many visual artists, mythologized, partially remembered motifs serve as markers of belonging within the unfamiliar cultural terrain of the diaspora. However, in the best of these arts, they are never quoted directly but rather incorporated into a highly syncretic aesthetic that draws as much from the experiences of displacement as from nostalgia for home.

With exile also comes a sense of freedom, what Caribbean writer George Lamming has called the "pleasures of exile," in which traditional constraints are lifted and the sensation of seeing all places as "foreign lands" is liberating.[5] Thus, experiences of diaspora also provide the space for the flowering of new creations and the transformation of artistic visions.

Of course, all these discussions of diaspora, exile and displacement have a particular profundity and poignancy with regard to Africa. For centuries, Africa has been shaped by histories of migration; lucrative trade across the Sahara in gold, slaves, salt and copper led to the rise of great kingdoms and centralized states based on the control of territory and resources. The great river systems and ports of Africa became vibrant lifelines between the material wealth of the interior and the continent's coastal regions and supported millions of small and large communities. Peoples, objects, ideas and technologies have long been moving, mixing and melding together to create the cosmopolitan, complex cultural formations seen throughout the continent. Needless to say, the closed tribal units envisioned by Europeans were figments of the colonial imagination.

As victims of the largest forced migration in human history, peoples of African descent make up a multifaceted, shifting diaspora. Considerations of cultural hybridity, fusion and invention are paramount to understanding the human consequences of the Middle Passage.[6] And it is in the fields of socio-cultural and art history that scholars have focused their attentions, investigating compelling yet diffuse connections between cultural traditions on the African continent and those that "survived" the Middle Passage.

Likewise, the history of the African diaspora is one filled with innovation, adaptation and the reconfiguration of distinctive cultural expressions. Finding and articulating notions of identity and voice in defiance of the systemic racist histories of America have been central concerns for diaspora artists and intellectuals. These assertions of voice and visibility have formed part of a larger set of cultural practices, referred to as "the Black Atlantic."[7] Within this space, one can approach the artistic and intellectual activities in the diaspora and on the continent as a single analytic field, in which ideas, peoples and objects have continually circulated and engaged with one another.

Africa's visual artists form an integral part of these traveling networks, frequently moving back and forth between "home" and abroad and often envisioning themselves as permanent sojourners in their diasporic homes.

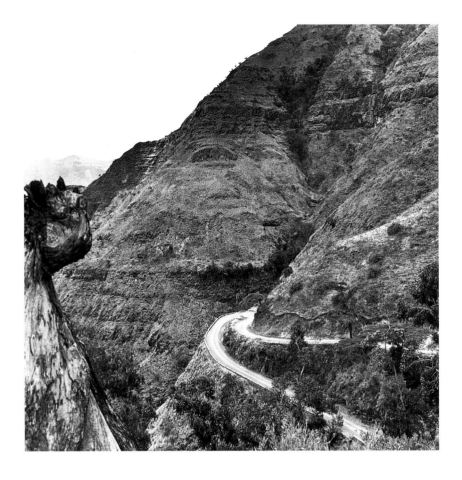

Fᴵɢ. 1
Ethiopian highlands
Photograph by Dimitrios E. Kyriazis
1950–74

Dimitrios E. Kyriazis Collection, Eliot Elisofon Photographic
Archives, National Museum of African Art

Contours of Diaspora

Ethiopians and Eritreans make up the largest group of Africans to resettle in the United States
under the Refugee Act of 1980. Until that date, this country did not have a refugee policy
for African asylum seekers. Close to 45,000 Africans were allowed to enter the U.S. between
1981 and 1984 as refugees; the majority were from the Horn of Africa.[8]

Like immigrants everywhere, Ethiopians sought to establish links to a community within
the diaspora, making Washington, D.C., and other cities like Dallas, Chicago, New York
and Los Angeles their home. Washington, D.C. has by far the largest population (in 1995 it
was estimated that about 75,000 Ethiopians lived in the United States, and among those,
at least a third lived in the Washington area).[9] The city's community supports five local
newspapers, a number of television and radio stations, and through its houses of worship
and community organizations, serves as the social and political hub of this diverse diaspora.

There have been a number of waves of migration from Ethiopia, paralleling the socio-
political history of the country. While the majority of Ethiopians in the diaspora certainly
arrived as a result of the upheavals associated with the 1974 military coup that ousted Emperor
Haile Selassie and ushered in 17 years of Marxist rule, others came seeking opportunities for
study and to join family members already relocated.

Since the 1960s, Washington has been the choice for Ethiopian elites and their children, who came to attend local schools. When Haile Selassie's regime was ousted a number of his supporters moved into the diaspora. In the late 1970s and early 1980s those persecuted under the military regime sought refuge, and in the late 1980s drought, famine, economic deprivation and the numerous secessionist battles taking place in various regions of Ethiopia forced a number of rural populations into the global flows of migration. Thus, within the diaspora, there are generations of migrants who carry with them their own histories and imaginings of home. The artists within this exhibition each had different reasons for joining the diaspora and have made different choices about their relationship to a broader Ethiopian diasporic community.

In order to understand the significance and breadth of the Ethiopian diaspora, it is necessary to draw a brief sketch of the social, political and historical circumstances that led to its development. The peoples of Ethiopia are a mix of diverse cultures, religions and ethnicities.[10] The Horn of Africa was one of the earliest areas of confluence in the world, crisscrossed by people moving on trade routes between Asia and Africa. In inscriptions dating from the 16th century B.C., the ancient Egyptians write of the land of "Punt," referring to the territories on either side of the Red Sea. It is generally thought that their expeditions in search of gold, ivory and slaves took them to the highlands of Ethiopia (fig. 1).

Ethiopia is distinguished for its early practice of Christianity. In 350 A.D. King Ezana converted to the faith to create the Ethiopian Orthodox Church. By the 5th century, the prosperous kingdom of Axum (fig. 2) controlled extensive trade links from the African interior

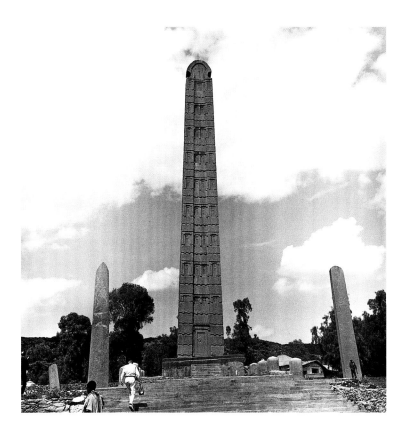

Fig. 2
Ruins at Axum
Photograph by Dimitrios E. Kyriazis
1950–74

Dimitrios E. Kyriazis Collection, Eliot Elisofon
Photographic Archives, National Museum of
African Art

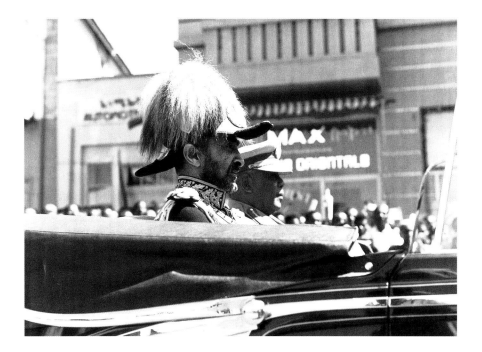

Fig. 3
Emperor Haile Selassie
Photograph by Dimitrios E. Kyriazis
1950–74

Dimitrios E. Kyriazis Collection, Eliot Elisofon Photographic
Archives, National Museum of African Art

to the Persian Gulf and the north shores of the Red Sea. Axum was established during the time of the apostles. St. Matthew was believed to have spent time there. It eventually fell from prominence in the 10th century because of the stranglehold that surrounding Muslim peoples began to exert upon its trade monopolies. It is also during this period that the myth of Prester John arose in Europe—a story of an embattled Christian king who could prove an important ally to Europe in the face of Muslim expansion.

Local tradition, dating from the 14th century, cites Menelik I as the divinely ordained first ruler of Ethiopia. Son of King Solomon (of Biblical significance) and the Queen of Sheba, Menelik was crowned King of Ethiopia. He was then believed to have brought the Ark of the Covenant to rest in Axum, where many believe it remains hidden today.[11]

Until the end of the 19th, century the core political unit of Ethiopia was a loose alliance of kingdoms. Ethiopian modern history began under the reign of Menelik II (1889–1913), a ruler perhaps best remembered for his victory over Italian invaders at the Battle of Adwa in 1896 that resulted in many European powers acknowledging the sovereignty of the kingdom. It was during Menelik II's reign that Addis Ababa (meaning "new flower") became the capital. Its prosperity and key location attracted many foreign embassies and the emperor encouraged European appointments to the court as advisors. His rule brought about a number of social innovations in the realm of education, postal services and medicine. Finally, it was under Menelik II that the important railroad was built between Djibouti and Addis Ababa.

During his illness, Menelik's wife, Empress Taitu, ruled for a time. After his death, various struggles ensued within the nobility until Ras Tafari Makonnen was chosen to become Emperor Haile Selassie (1930–74). The emperor (fig. 3) went into exile and the Italians occupied Addis Ababa between 1936 and 1941.

This autocratic and charismatic ruler called himself "Elect God, King of Kings of Ethiopia" and the "Conquering Lion of the Tribe of Judah." The modernization programs begun by his predecessor were expanded under Emperor Haile Selassie. Writer and poet Solomon Deressa perhaps best describes the atmosphere under Haile Selassie's reign, during which the ruler was able to promote his country internationally at the League of Nations, attract foreign investment and found the important Organization of African States in 1963.

. . . in the sixties and early seventies, Addis Ababa was home to almost seventy embassies, half a dozen international organizations, thousands of expatriates of every nationality, art galleries, theater groups, traditional orchestras and pop bands, a medley militia of writers and poets, and a small but growing bourgeoisie able and willing to support much of the activities that these groups generated.[12]

This was the era in which the great early modernist painters and poets flourished. But it was also a time in which the feudal aristocracy, church, local gentry and military owned 70 percent of the land, while 85 percent of the people had to make due with the remaining 30 percent. In 1973, hundreds of thousands died from a famine in the north. Haile Selassie's social reforms primarily benefited the circle of nobles around him. Dissatisfaction with the inequalities of the imperial system and the privileges afforded the nobility and Church led to popular protests against the regime.

In 1974, the Derg (Amharic for "committee" or "council") launched what has been called a "creeping coup," advancing a series of directives and actions by which the imperial system was slowly dismantled, leaving the emperor and his supporters powerless and illegitimized. First, this military provisional government lobbied for a new constitution and freedom for political prisoners. They then began to disband and dismantle all the emperor's governing councils, closed the private exchequer and nationalized the imperial residence, lands and other business holdings. The emperor was imprisoned and Mengistu Haile Mariam became the leader of the nation. Promoting *Ye-Ithiopia Hibretesebawinet* (Ethiopian socialism), the Derg was fond of slogans of self-reliance, the dignity of labor and the supremacy of the common good. Many of these ideas were designed to counteract the widespread disdain of manual labor and concern over status. Land reform was a major goal of Ethiopian socialism. In May 1975, the government radically achieved this reform in one fell swoop, nationalizing all rural lands, abolishing tenancy and putting peasants in charge of enforcement. Urban populations were organized into neighborhood associations known as *kebeles* and many were forced into national service to wage war against several nationalist and anti-regime forces.

The grimmest period under Mengistu's rule came with the "The Red Terror" (December 1977–February 1978), a government campaign to stamp out opposition from student groups, alternative socialist reform parties and ethnic groups. Over 5,000 lives were lost and almost an entire generation of youth and intellectuals was wiped out. Family and friends were made enemies as terror spread through the population and no one was sure whom to trust. Tragically the socialist movement, which many of the nation's most promising youth had joined out of compassion for the poor and ideological beliefs, led to great brutalities and the wounding of a generation. The 17 years of Marxist dictatorship left the country in ruins.

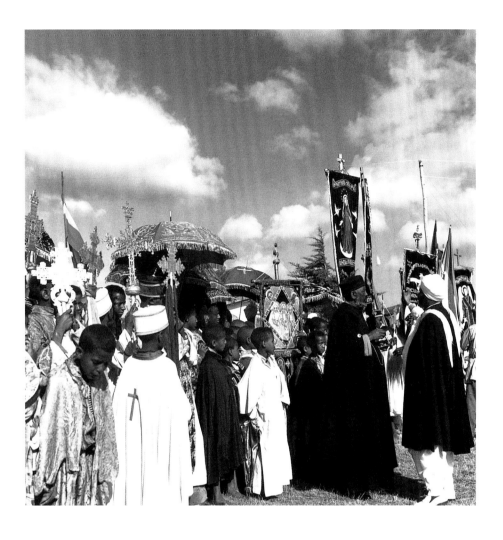

FIG. 4
Religious procession
Photograph by Dimitrios E. Kyriazis
1950–74

Dimitrios E. Kyriazis Collection, Eliot Elisofon
Photographic Archives, National Museum of
African Art

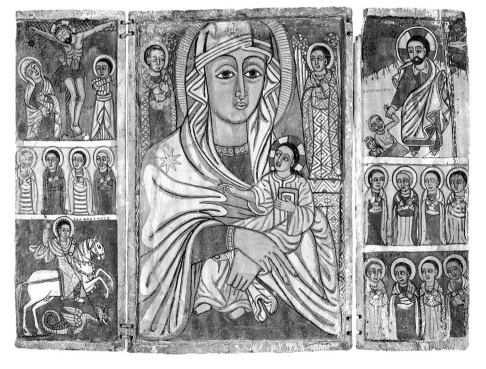

FIG. 5
Icon
Ethiopian Orthodox style
c. 1750–1855
Distemper and gesso on wood
34 x 47 x 17 cm (13 x 18½ x 6½ in.)

National Museum of African Art, gift of
Ciro R. Taddeo, 98-3-2

Politics at home have cast a long shadow across the diaspora in which the sores continue to fester. The layering of histories within this broad diaspora thus complicates expressions of identity and feelings about community.

Ethiopia and Art History

Ethiopia is perhaps best known for its long tradition of ecclesiastical arts, such as processional and hand silver crosses, sistra, bells, chandeliers in gold, silver and bronze, paintings, icons, scrolls and manuscripts filled with the cursive script of Ge'ez, the indigenous liturgical script that informed modern Amharic (figs. 4 & 5). The architectural wonders of Axum and Gondar, along with the 11 rock-hewn churches built by King Lalibela in the 12th and 13th centuries, also figure prominently in accounts of Ethiopian art histories.

The earliest church murals date to between the 13th and 16th centuries. Their iconography, palette, composition and perspective illustrate long-standing links to Byzantium. It is to these murals and to the rich histories of magic scrolls and religious icons that many of Ethiopia's modern artists have been drawn for cultural inspiration.

There are three figures who are considered to be the pioneers of modern arts in Ethiopia—Alexander "Skunder" Boghossian, Gebre Kristos Desta and Afewerk Tekle. Afewerk helped to shape the place of the modern artist in Ethiopia, although his aesthetic is not modernist but rather closer to 19th-century academic realism.[13] While primarily painters, both Skunder Boghossian and Gebre Kristos Desta explored mixed media with some wonderful results. Skunder Boghossian is the only living diaspora artist amongst the three and participates in this exhibition.

To many, Skunder represents the quintessential Ethiopian and African modernist (see "Ethiopian Diaspora and the Visual Arts"), a pioneer whose shoes have been difficult to fill. Critics, admirers, friends and competitors assert that Skunder Boghossian "is a painter of as high an order as any that the second half of . . . [the 20th century] . . . has seen in any country, on any continent." He has been called the "most significant Ethiopian painter since the glorious 18th-century Gondarine period, but also primary heir to all the traditions of Ethiopian art."[14] Almost 35 years later, history still remembers Skunder Boghossian's groundbreaking solo exhibition in Addis Ababa (1966). Stanislaus Chojnacki recalls: "We saw for the first time in this city an entirely new aspect of art, joyfully refreshing, immensely inspiring and truly original."[15]

Skunder had early works collected by the Musée d'Art Moderne in Paris (1963) and the Museum of Modern Art in New York (1965). He has had an illustrious career, serving as mentor, colleague and doyen of the African modern arts scene. But it is important to note that as a pioneer, he remains a figure to whom artists situate themselves and their work. Some have argued that his talent and success have dwarfed the productions of others. His teaching position at Howard University in Washington, D.C., made him a central figure within the expatriate Ethiopian community and a number of artists followed him to Howard to study. Wendy Kindred has argued that "No Ethiopian painter of the generation following

Boghossian has moved in a direction as powerful and personal as Skunder's. Most persist in the belief that Boghossian's personal vocabulary is common property, a generic Ethiopian product available for their use."[16]

Six of the 10 artists in this exhibition have attended Howard. Their originality of vision, iconography, approach to materials and artistry are testaments to the narrowness of Kindred's statement. While there may have been some who were unable to move beyond mimicking the artistry of the master Skunder, the diaspora, in fact, consists of many who never studied with him while at Howard but forged their own ways vis à vis their Ethiopian heritage, modernist histories, experiences of exile and contemporary artistic practices.[17] (See "Howard University, Ethiopia and Ethiopianism" and "Ethiopian Diaspora and the Visual Arts" for a discussion about the importance of the Howard visual arts department in this story of diaspora and visual practice.)

The other significant pioneer of Ethiopian modernism, painter and poet Gebre Kristos Desta, moved in and out of the diaspora for study and political reasons. Born in 1932 in the southwestern province of Harar, Gebre Kristos was the son of a clergyman and a church illustrator who created religious books and parchments and worked for Ras Mekonnen, then governor of Harar and father of Haile Selassie. After studying agricultural science at the

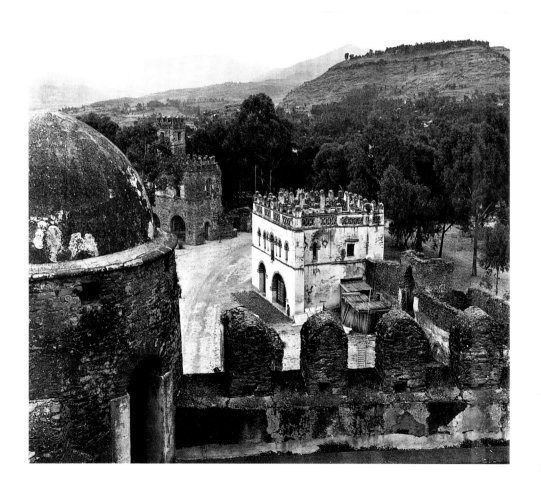

Fig. 6
Ancient city of Gondar
Photograph by Dimitrios E. Kyriazis
1950–74

Dimitrios E. Kyriazis Collection, Eliot Elisofon Photographic Archives, National Museum of African Art

university in Addis Ababa, Gebre Kristos won a scholarship to study at the Academy of Art in Cologne from 1957 to 1961. He was greatly involved in the Abstract Expressionist movement while in Germany and returned in 1963 to teach at the School of Fine Arts in Addis Ababa. In 1965 he won the Haile Selassie I Prize Trust Award for Fine Arts for being "largely responsible for introducing non-figurative art into [the] country" and for having "outstandingly contributed [to] the growth and evolution of Ethiopian Art."[18] Unwilling to continue to participate in the Derg's socialist programs, Gebre Kristos sought refugee status in the U.S. and died in Oklahoma in 1981.

The fate of these early modernists under the Mengistu regime was tied to the socialist agenda. The government's policies towards the arts, known as *zamacha*, or the National Campaign for Education through Cooperation, dispersed students and faculty to rural areas to propagate revolution. Art was to serve as an instrument of political education of the masses. Prop-Art was greatly encouraged.

Internationally acclaimed modernist artists were criticized in official statements for illustrating " . . . little or no sense of artistic responsibility to society."[19] It was only a matter of time before artists sought greater freedoms. Those already residing abroad were, in effect, exiled from Ethiopia.[20]

It is an interesting time in Ethiopian diasporic history to mount this exhibition. Since the fall of the Marxist military regime many artists have returned from imposed exile to visit or, in some cases, relocate to Ethiopia.[21] The flow of ideas between Ethiopia and the broader world has also increased. In fact, the majority of artists featured in this exhibition have traveled extensively to Ethiopia in the last few years, some, like Aida Muluneh, for the first time. As Mickaël Bethe-Selassié explained of his decision to travel (fig. 6):

> Yes, it had been two years since the change in Regime, in November 1993 I went back. I needed to return to Ethiopia to gain a certain inspiration, in the ancient churches, the castles. I knew that I would see them differently, no longer like the clichés or fantasies born of exile, but as true cultural sources.[22]

The Artists

The massive, turbulent canvases and wall drawings of **Julie Mehretu** provide a good starting point for investigating the works of these 10 artists. Her explorations of the character of transnational movements, the forces of globalization and the fast-paced nature of 21st-century urban life are controlled maelstroms of color and line (plate 1).

Mehretu has forged a new tradition of landscape painting—one with a language of forms that includes architectural plans, topographical and airport maps, weather charts, street grids, animated explosions and popular culture imagery—everything from tattoos to graffiti, science fiction elements to Kung Fu kicks. The overlapping maps and architectural fragments, suspended in the artist's painted world, often envelop concentrations of delicate ink hatch marks applied with meticulous attention (plate 2).

Fig. 7
Julie Mehretu
Urgent Painting
2001
Ink

Site-specific installation,
Musée d'Art Moderne de la
Ville de Paris

These small details of line provide us with an intimate encounter with what otherwise are grand-scale works. The artist sees these hatchings as individuals who populate her landscapes—their forms represent the raised fists of the masses, marching in protest, urban crowd scenes, the barrels of guerilla fighters' guns, the curved backs of toiling workers or the huddled masses bent in unison in prayer at Mecca.

Through layers of vellum, mylar, paper, acrylic and ink, Mehretu is thus able to tell us of the grand narratives of history—mass migrations, the rise and fall of great civilizations or the power and urgency of opposition movements. The artist explains: "I am hoping that the paintings operate in a Baroque, over-the-top epic narrative. I look at them as current historical narrative paintings, pulling from the likes of Delacroix."[23]

She has described her paintings as "story maps of no location" and through them she enables us to think about the physical and psychological effects of migrancy and dislocation and the sense of liminality felt by those on the move. In Mehretu's painted worlds, time and space are in constant flux. Juxtapositions, reversals, elisions and erasures are commonplace.

Mapping, of course, is a means of claiming and controlling space. While the maps and architectural plans that Mehretu employs are those created by governments or others in control of public spaces, each of us is constantly in the process of creating mental maps,

demarcating the familiar in our lives. In an era where attachments to a single homeland are becoming more rare, mapping becomes a key tool in relocating one's position in the world and understanding one's place in a community (plate 3, fig. 7). Mehretu explains: "I am interested in the multifaceted layers of place, space, and time that impact the formation of personal and communal identity."[24]

In *Thirdspace*, urban geographer Edward Soja introduces a new discourse on geography in which he sees space as an integral part of understanding the interconnectedness of our global society. He writes:

. . . the spatial dimension of our lives has never been of greater practical and political relevance than it is today. Whether we are attempting to deal with the increasing intervention of electronic media in our daily routines; seeking ways to act politically to deal with the growing problems of poverty, racism, sexual discrimination, and environmental degradation; or trying to understand the multiplying geopolitical conflicts around the globe, we are becoming increasingly aware that we are, and always have been, intrinsically spatial beings, active participants in the social construction of our embracing spatialities.[25]

Mehretu's canvases and wall paintings provide us with insight to our own uses of space in this global age.

Of course, the ease with which Mehretu articulates her understandings of diasporas and transnationalism is rooted in her own experiences. Born in Addis Ababa in 1970 to an Ethiopian father, who was a professor of geography, and an American mother, Mehretu lived in Senegal and later received her BFA from Kalamazoo College when her father's career relocated the family to East Lansing, Michigan. She then moved to the East Coast to study for an MFA at the Rhode Island School of Design. After several years in the Houston area, where she took part in the Core Artists-in-Residence Program, she finally set up a studio in New York, itself a city of immigrants.

Mehretu's history and practice illustrate the fluid, shifting and highly personal means through which individuals negotiate definitions of diaspora. While she clearly feels an affinity and connection to things Ethiopian, her works move beyond any narrow definition and speak to global concerns.

Also, while her choice of medium is traditional and she admits a desire to engage with the rich history of painting practice, her iconography and her technique (which includes computer assistance) are purely her own, born of the freedoms that the global age has afforded her. One of Mehretu's future projects will be a series of epic paintings that address the spaces of Africa's postcolonial cities, themselves rich mixes of cultures, traditions and histories.

While Julie Mehretu's works offer us a kind of bird's-eye view of the structures of a transnational world, the art of **Kebedech Tekleab** provides us with a window into the souls of the displaced. In her large, haunting, painterly canvases, Kebedech addresses the agony of human oppression and the dignified resilience of its victims (plate 4). Many of the human

tragedies of the 20th century occurred as a result of brutal warfare or economic or ecological strife. Like many contemporary artists in exile, Kebedech has struggled to find peace in the face of life's vicissitudes and, through visual art and poetry, has been able to come to terms with its bittersweet realities, using autobiography to address shared histories. As she states in "A Long Walk in the Light of Art" (artist's statement, 2002):

> I am fascinated by the duality of life—the benevolence and the cruelty, the good and the bad, the darkness and the light—My art is a reflection of life that draws from this reality. It is done rationally and emotionally, embracing the bitter taste of life while yielding an aesthetic beauty of its own.

Born and raised in Addis Ababa, Kebedech began her artistic studies in the early 1970s, but they were cut short by the rise of the Derg. At 17, she left school to join a student movement that rose in opposition to the military regime.[26]

As the government began to systematically wipe out its opposition, she, like many of her generation, was forced to flee the capital and the country. En route to Djibouti she was caught by the Somalian Liberation Movement and placed in a labor camp where she remained for over a decade until her repatriation in 1988. Although she escaped most of the physical abuse of the camps, working as a nurse and creating portraits of her captors, she experienced the psychological terror. After repatriation, Kebedech joined her family in Washington, D.C. in 1989 and resumed her art studies in 1990. She received her bachelors in 1992 and a masters in 1995 from Howard University.

At a certain point during her time at Howard, her paintings became more abstract; the figures began to lose their faces. The pain that she transferred to them was such that it became more effective to think about the soul within the figures than the identity of the figures themselves. For Kebedech, the dehumanizing and degrading experiences of war and refugeeism were better articulated through abstracted figuration. Her *Human Condition* series, of which *Shackled* and *The River in Rwanda* (plate 5) are parts, arose from her reflections at Howard.

> I tried to find parallels between poems I had written and my paintings. Internally, instead of visualizing the physical body, I began to sense the feelings, as if the numbness that I had was becoming less as the pressure that pinched its sensitivity was overcome. The use of human figures became a secondary means of expressing emotion. Since I started reliving the life that I earlier had lived emotionally, my mental picture of people whom I had once known only superficially became transformed to a sense of their souls. From the cause to the effects.[27]

Kebedech produced the *Powwow* series in the early 1990s; a set of paintings that eventually served as part of her masters requirements. After a friend invited her for a visit in North Dakota, Kebedech met with a series of Native American elders, observing their community and their celebrations. Learning about their powwows, the artist was taken by the sophistication

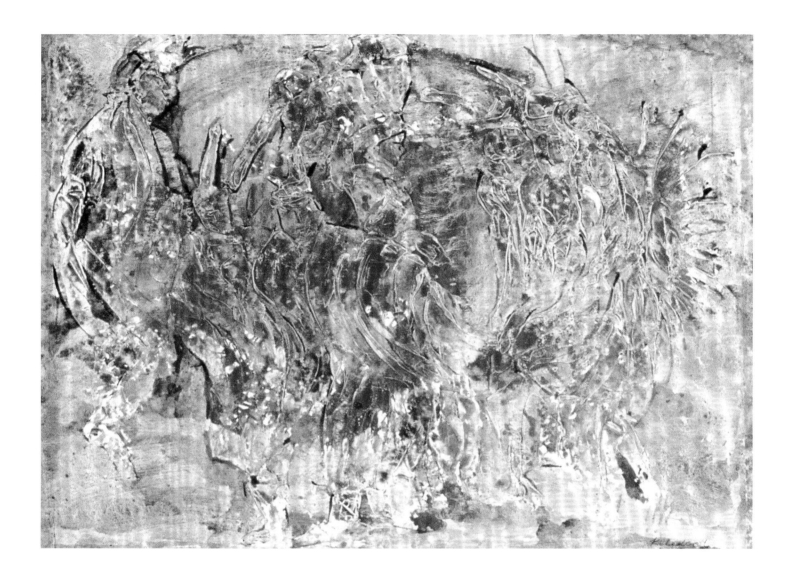

FIG. 8
Kebedech Tekleab
The Power
1993
Mixed media
on canvas
173 x 105.5 cm
(68 x 41 in.)
Collection of
the artist

of these cultures and, in her series of paintings, returned to a previous theme of "civilization versus savagery" (fig. 8).

Kebedech's paintings are highly textured compositions within which forms are delineated through a strong sense of line and often bled to the edges of the canvas, as if threatening to join the surrounding world. Her painterly style, which is complemented by subtle and thoughtful uses of color, gives her forms a visceral quality. She says of her painting:

In my effort to address human suffering as it might present itself to others in the world, I chose the art of painting as a medium of expression. This I did in two ways: first, by focusing on the similarities between my experience and the histories of human suffering in other parts of the world; and second, by examining the deleterious consequences of the notion of "Civilization versus savagery" which has been widely used to justify genocide on the part of the "civilized."[28]

It is of little surprise that in her reflections and her poetry Kebedech Tekleab has been drawn to the grandiose, dark and bloody canvases of Francisco Goya and Diego Velasquez whose works address war, human tragedy and frailty (plate 6). In her poem, "To Francisco Goya's painting 'The Third of May,' 1808,"[29] she writes:

How true it is,
Goya
How True!
'Tis the way to face death,
For the enemy's missile
Impotent in the realm of ideas,
Can but strike at its target of tangible flesh
And leave unscathed the abstract tenet.
'Tis when the flesh alone is mortal
That courage can stare death in the eye
And bare its chest to the terrible messenger
Dispatched by the horrible bark and blinding flash
From the muzzle of the gun
How true it is,
Goya,
How true!
It is darkness,
As for war,
It is but darkness,
Where the butcher and the butchered
Discern one another in the twilight of hatred.
How true!
(Translation by Abiyi Ford)

The synergy between Kebedech's poetry and visual works is obvious. They nourish and often parallel one another and serve as means through which the artist is able to transform trauma into a terrifying but beautiful vision, to make sense, somehow, of the madness in which humans have engaged.

In *Shackled*, Kebedech alludes to the cruelties and inhumanity of confinement. The dismembered, twisted, voluminous body parts, and the chaos they have endured threaten to spill beyond the confines of this highly textured and subtly hued canvas. Kebedech writes of her works: "The challenge for me as a painter has been how to reconcile the differing dynamics of tragedy and the sublime on one picture plane." She poses the question: "Is it possible to express tragic situations beautifully? Can I do justice to the tragic situation if my paintings are not shocking enough to reflect the inhumanity of the act they would comment upon?"[30]

The River in Rwanda is a disturbing account of genocide that occurred in 1994 in the small central African nation. A tragedy born of economic failure and ethnic conflict, this

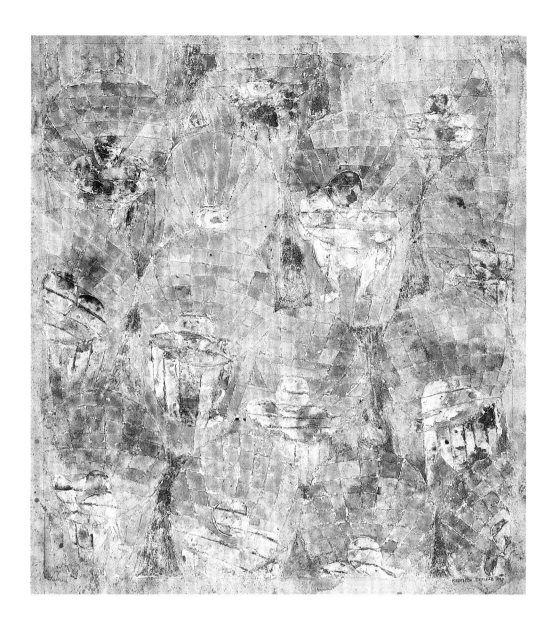

genocide had its roots in colonial politics in which the Belgians favored the minority Tutsis over the Hutus and fomented interethnic tension by propagating a racist myth of Hamitic superiority. Kebedech found within the story of Rwanda parallels to her own experiences of flight and internment in a Somalian labor camp and memories of the Red Terror under the Derg. She depicts this carnage through the assemblage of bodies, bones and blood that filled the rivers in Rwanda. The texture and palette of the work enhance its visceral impact.

When faced with experiences of displacement, exile and loss, émigrés seek a means to restore a sense of sanity, safety and belonging.[31] Through the rounded, contemplative figures and soft palette of *Insulated* (fig. 9), Kebedech extends an olive branch to the world, acknowledging the need for self-preservation within the whole, for individualism within the community and for benevolence and aesthetic beauty amidst the bittersweet realities of the 20th century. She writes of *Insulated*:

It is the oppressors who are insane
Consumed by the wounds of their conscience
The victims do not have blood on their hands
They are as pure as the black sky
As clear as the myriad white stars
Vividly showing the scab of a wounded life
(Translation by Tadessa Adera)

Elizabeth Habte Wold creates delicate compositions, utilizing collage or soft gouaches to detail experiences common to diasporic life. Wold's compositions show a great sense of graphic design and a sophisticated understanding of materials. Trained as a computer graphic artist as well as a painter, Wold's knowledge of technology has afforded her a keen comprehension of space, perspective and form in her handling of the modernist medium of collage. Wold came to collage work by necessity and example. After her time at Howard's fine arts department, she had little money for materials. In the process of looking for a job, she had amassed stacks of newspapers in her home. One day, anxious to create, she began to toy with the materials, cognizant especially of the great collages of Romare Bearden, about whose work she had learned while at Howard.

Collage became an ideal medium through which she could tell her poignant stories of loss, dislocation, and generational disjuncture that are the result of diaspora and exile (fig. 10). Through the juxtaposition and mixing of disparate materials, Bearden created powerful artworks. He used the medium to tell the stories of the difficult everyday lives of African Americans as they followed the Great Migration north and searched for freedoms in America. Bearden's uses of collage and photomontage enabled him to give visibility to a large population and form to their struggles. Likewise, Wold's use of collage elements, gathered from the mass media, highlights the ironies of the age of globalization, the contingency and fragility of life and the stories of countless émigrés.

These stories are told in small scale, maintaining a sense of intimacy. Through them, Elizabeth Habte Wold is able to suggest the importance of community and imaginings of "home" in this age of movement. Like a number of her colleagues within this exhibition,

Fig. 10
Elizabeth Habte Wold
Journey I
1996
Collage
61 x 30.5 cm
(24 x 12 in.)
Collection of the artist

she focuses upon the stories of women within the diaspora who are the survivors of globalization's effects.

In *Lonely Mother* (plate 7), Wold focuses upon the sense of rupture, fragmentation and longing for home that plays an integral part of transnational stories of migration in contemporary history and in regards to the Ethiopian diaspora in particular. She also addresses the generational splits that occur within these diaspora communities as the youth toil to succeed in a new society while the older generation, alienated by linguistic and cultural barriers, sits desolate and alone awaiting the return of their children and remembering the community they left behind. Wold herself left Ethiopia to join her family in the Baltimore/Washington area after receiving a diploma from the School of Fine Arts in Addis Ababa and encouragement from Wosene Kosrof, her art teacher in secondary school.

In the *Forgotten Souls* series (plate 8, fig. 11), the artist worked from sketches she had made outside a church in Addis Ababa. Many impoverished people gathered around the church seeking alms. Wold's characters seem defeated by the mechanisms of global consumerism and capitalism, which have led to a century of mass migrations and displacement and served to further delineate the haves from the have-nots. In her delicate gouache, *The Three Women* (plate 9), Wold depicts three figures engaged in intimate conversation. Like her collages, Wold's work in gouache is executed with sensitive manipulation of texture and a simplicity of line that gives elegance to this everyday scene.

As artists cross frontiers, they bring with them their memories and stories—their ties to "home." Like many in diasporas throughout the globe, contemporary Ethiopian artists have

Fig. 11
Elizabeth Habte Wold
Forgotten Souls II
1993
Mixed media collage
and graphite on paper
34 x 52 cm
(13 x 20½ in.)
Collection of the artist

actively, innovatively and consistently used memory as a tool to situate themselves and their artistry within a broader context.

Skunder Boghossian has been masterful at imagining aspects of Ethiopia's and Africa's cultural heritage within his works. His skill derives from the insightful manner in which he is able to recall broad-ranging visual motifs, myths and calligraphic forms. He shifts them into a textured universe that is purely his own, and yet one that can be experienced by Ethiopian and global audiences alike.

Skunder left Ethiopia at the age of 15 on a scholarship from the emperor to study in London. He soon found himself within the exciting intellectual and artistic circles of Paris in the late 1950s and 1960s where the proponents of the Négritude movement and pan-Africanist ideals were ensconced. Invited to exhibit at the famous 1959 Artists and Writers Conference, sponsored by Présence Africaine, in Rome, a young Skunder was able to rub shoulders with the luminaries of the black arts world—Leopold Senghor, Alioune Diop, Richard Wright, Aimé Césaire and fellow visual artist Gerard Sekoto—amongst others.

Schooled as much in this atmosphere of pan-African self-consciousness and anti-colonial sentiments as in the formal classes at Académie de la Grande Chaumière, Skunder attained an enduring sense of self and a passion for black culture. As friend and poet Solomon Deressa noted: "There are indeed vantage points from which the world appears black—and not half-bad at that. Paris of the mid-sixties was it."[32] It was also in Paris where Skunder could follow his early affiliation to jazz, immersing himself in the vibrant clubs of the city.

Jazz, the supreme creation of a people in exile, opened Skunder to his own experiences of exile from home life and an Ethiopia that were less nurturing to his need for independence and exploration.[33]

The artistic scene of Paris also brought this young painter in contact with the arts and ideas of great modernists such as Max Ernst, Pablo Picasso, André Breton, Paul Klee and Wilfredo Lam. It is to Wilfredo Lam and Paul Klee that Skunder's works are often compared. The surrealist works of Lam, an innovative Cuban artist who was a contemporary and collaborator with Picasso, enabled Skunder to envision how one could create a hybrid visual language of African modernism. [34]

In 1966, Skunder returned to Ethiopia to teach at the School of Fine Arts and immersed himself in the traditional arts of his homeland, seeing with new eyes the magic scrolls, church paintings and myths of the cultures from which he had been so long absent. He stayed only three years but, through exhibition, teaching and fellowship, he left an indelible mark on the Addis Ababa arts scene. Moving to United States in the late 1960s—Atlanta, New York City, Washington, D.C.—he was immersed in the era of Civil Rights and Black Power. For Skunder, these historical events were, in many ways, natural progressions from the experiences he had had in Paris. They allowed him to expand his visual vocabulary and interests into the black diaspora.

Skunder's true genius lies in his ability to draw together wide-ranging iconography into a framework that is enlivened by a great attention to texture, color and form. Whether he is

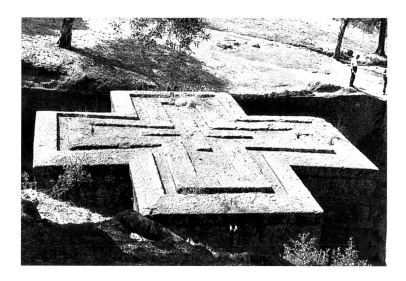

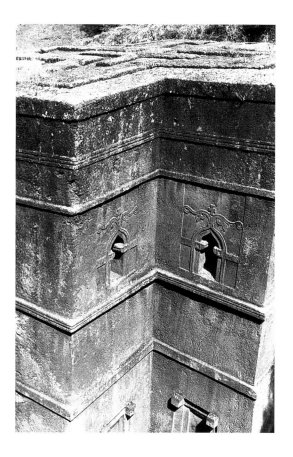

Figs. 12 & 13
Rock-hewn church (c. 13th century)
in Lalibela, Bet Giorgis
Photograph by Dimitrios E. Kyriazis
1950–74

Dimitrios E. Kyriazis Collection, Eliot Elisofon
Photographic Archives, National Museum of
African Art

producing grand works such as *Juju's Flight of Dread and Delight* and *The End of the Beginning* or gives us delicate, thoughtful canvases such as *Jacob's Ladder* and *Composition II*, Skunder's understandings of his materials and interest in the cosmological and mythical elements of our existence lead to powerful works.

The End of the Beginning (plate 10) depicts the burning of Axum and Lalibela (figs. 12 & 13), two historically significant sites in Ethiopia. Here, Skunder prefigures the Ethiopian revolution of 1974 and illustrates the overturning of Church and Imperial hegemony in modern Ethiopia. The white bird in the center, poised as a phoenix, is witness to and survivor of the destruction, while the spirit figure on the right represents the past hoping to escape the violent present. Skunder has deconstructed spatial order to convey a sense of collision and shock, a metaphor for revolution and change.

During a trip to Uganda, Skunder collected bark that was used locally for burial. He worked the bark into a somber, totemic composition, one that derives its strength as much from the beauty of the material's natural hues and textures as from the mysterious forms with which he endows it. In *Time Cycle III* (plate 11), one senses a profound narrative about the grandness of Mother Nature complete with volcanoes, lava flows and mountain formations.[35] Skunder's ongoing fascination with the cosmological is given an abstract, lyrical form.

The small, delicate works of *Jacob's Ladder* (plate 12) and *Composition II* (fig. 14) illustrate the artist's masterful comprehension of the alchemy of painting, through which

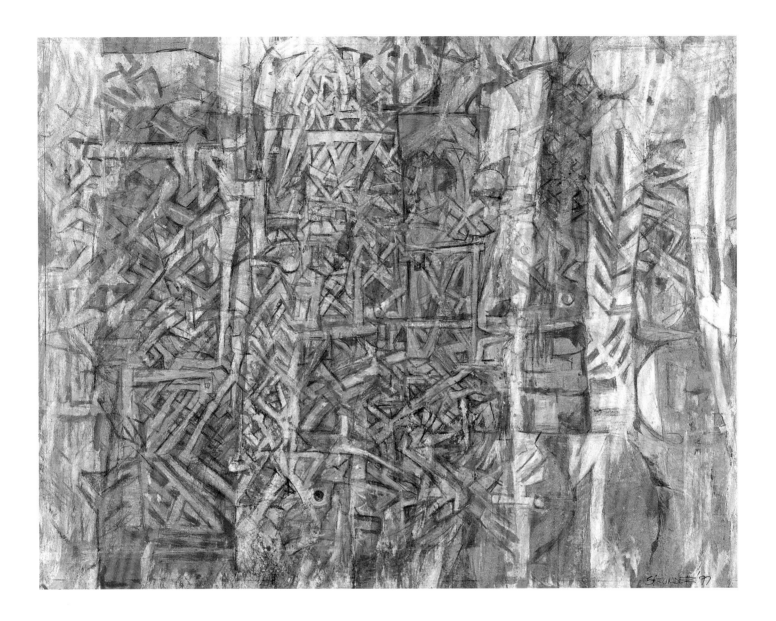

FIG. 14
Alexander "Skunder"
Boghossian
Composition II
1997
Acrylic on paper
53 x 69 cm
(21 x 27 in.)
Collection of the artist

sophisticated and sensitive investigations of color and texture create a mystical universe. One can easily imagine the extension of Jacob's ladder from Earth to Heaven in the former and the ghost of Wilfredo Lam in the latter.

Like her compatriots, **Elisabeth Atnafu** subtly mines the art history of the home she left behind and places its features in dialogue with a diverse range of cultural traditions. While providing a means of artistic and personal inspiration, the power of memory is, for Atnafu, grounded in the way in which it is shared. Thus her works are invitations to tell stories, to honor the oral histories of those who move across the globe with little but their memories to help place themselves in the world.

As a teenager, Elisabeth Atnafu left Ethiopia to join her four older siblings in Washington, D.C. She grew up in an artistically oriented family, with a father who was an amateur painter and furniture maker and older sister who was the first female to enroll in the School of Fine Arts in Addis Ababa. Atnafu is a pioneering member of the Ethiopian diaspora arts scene,

for she was the only female artist who achieved early success, working and exhibiting amongst men.

Atnafu admired Skunder Boghossian and Gebre Kristos Desta while in Addis Ababa and, although younger, became their colleague in the diaspora. Atnafu's artistry benefited from the atmosphere that poet Solomon Deressa has labeled the "Indian Summer" of Ethiopian history—a heady time for the arts, just before the fall of the emperor when galleries and theater troupes, writers and poets and visual artists all gathered, supported by a growing bourgeoisie. Young modernists, just returned from schooling in Europe, mined the traditional motifs of their heritage, immersed themselves in the wonders of Lalibela, Gondar and Axum and sought to bring a medieval kingdom into the 20th century.

After completing a BFA at Howard in 1974, Atnafu moved to New York City and participated in the vibrant art scene before returning to Howard to pursue an MFA in the early 1990s. While earning her second degree, she spent many days in Skunder's studio, exchanging ideas, learning informally from him as a colleague rather than a student.

When writing of Atnafu's works, many have emphasized the mystical, dreamlike quality of her imagery, which draws upon not only the traditional liturgical symbols of Ethiopia but also upon many of the popular elements of Christianity in Ethiopia and elsewhere. Her vibrant color schemes and bold brushstrokes suggest lovely comparisons with the mystical works of Franz Marc and Wassily Kandinsky. Indeed, her aesthetic also has parallels to the great action painting of Willem de Kooning. In *Haunted Forest* (plate 13), Atnafu demonstrates her great skill with brush and composition, creating a richly colored, enchanted landscape in which fantastical creatures inhabit thick, luscious vegetation. But formal comparisons aside, Atnafu's works are much more than simply a latter day engagement with the spiritual concerns of the Blaue Reiter group. She skillfully re-imagines home, using notions of memory and storytelling as tools in the process. As Salah Hassan has said of her works:

> *Atnafu's reference to her heritage is not the sort of "return to sources" escapism that has characterized the products of certain postcolonial intellectuals of the Third World, but a serious exploration of one's heritage and past accomplishments, with an eye to synthesizing the old and creating the new.*[36]

While her works draw upon myths and legends of home, like that of the Queen of Sheba, she also engages with traditions of witchcraft, narratives surrounding the evil eye, magical practices of spirits and local saints. Understanding and memory of the popular belief systems are then fused with similar traditions from Latin America and elsewhere to create syncretic post-modern pastiches that speak about spirituality and individualism and about the malleability of traditions.

There is a performative and theatrical aspect to all of her works. Many are concerned with the lives and stories of women in diasporic, urban conditions, like those in which she lives. Atnafu creates her artworks as offerings to a world that needs to remember, needs to tell its stories and needs to dream of new realities. In her studio are stacked parts of an intimate, engaging series of works created from used cigar boxes upon which the artist has

created visual images and left room inside for her audience to write an accompanying interpretative, reaction piece. She thus participates in an illustrious history of those who fuse the visual with the written (e.g., Gebre Kristos Desta, Wosene Kosrof and Kebedech Tekleab), a practice that has interesting precedents not only in the world of modern art but also of course in the traditional arts of Ethiopia where church illustrators created images to tell the Bible's stories to the illiterate. In her work *Dream Dancers* (plate 14), Atnafu invites audiences to invent a narrative for each of the different female figures dancing within their rice paper compositions. This and other works were inspired by the young women who she encountered entering the rehabilitation centers for drug users on Manhattan's Lower East Side.

Like many of her works, *Shrine for Angelica's Dreams* (plate 15) honors the forgotten stories and quotidian experiences of immigrant life. This piece recalls the aspirations and tribulations of Angelica, Elisabeth Atnafu's South American hairdresser. She employs Angelica's stories to comment upon the important role of memory and narrative in the lives of those with diasporic histories. The dress, hung against a brilliant blue canvas fringed with lace and topped with wire hat, incorporates a plethora of objects on its surface, ranging from talismans to beads to toy soldiers. The effect is reminiscent of a hunter's shirt or a liturgical vestment, wherein each object serves as a metonym of cultural and religious significance.

In *The Sanctuary* (fig. 15), Atnafu reconfigures and re-imagines the traditional interaction between pilgrim and holy site, incorporating a wide variety of motifs ranging from traditional Ethiopian iconographic painting to historical photography. While the piece clearly alludes to the great historical church paintings at Lalibela and Gondar, she is able to broaden its impact to address the process of worship and need for community that is common across cultures.

Many artists have given voice and visibility to the individuals within the diaspora, allowing us to better comprehend the human dimensions of migration and resettlement. The characters that form part of Etiyé Dimma Poulsen's artistic universe and the women captured by Aida Muluneh's camera lens give texture and substance to the experiences of diaspora; they help us determine how one defines belonging and a sense of self within a transnational contemporary world.

Etiyé Dimma Poulsen is a young, self-taught sculptor who creates out of iron mesh, clay and glazes, marvelous personnages that face the world with a quiet dignity and elegance. These works have been compared alternatively to Modigliani's elegant, elongated figures or to East African grave markers but Poulsen's technique, clarity of vision and willingness to accept the randomness of ceramic firings have resulted in an impressive aesthetic that is highly personal. Orphaned young, Poulsen and many of her siblings were adopted by a Danish missionary and his wife. She spent much of her childhood moving around East Africa and finally settled in a small town in Denmark. Her diasporic experiences have thus been characterized by short and long journeys, across a number of cultures and continents.

She sees her interest in arts to be a natural result of this history of displacement.

Travelling with my family from one place to the other, I remember feeling a tremendous sense of uprootedness, a deep sense of isolation, and serious problems of communication, or one might say, miscommunication. I could not express myself and that is probably why

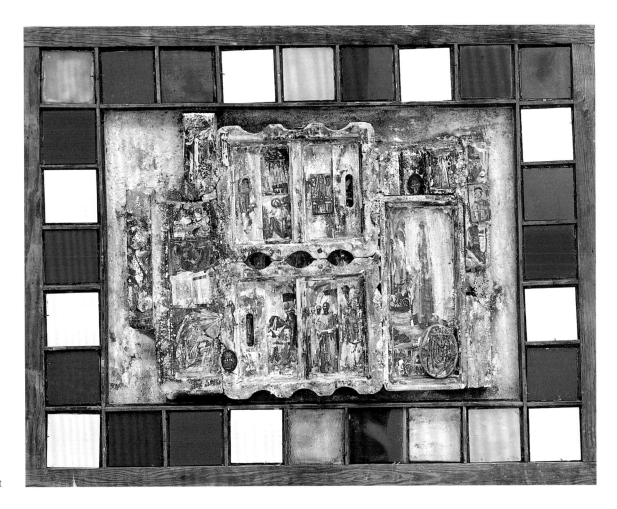

FIG. 15
Elisabeth Atnafu
The Sanctuary
2002
Mixed media
91 x 106.5 x 6 cm
(36 x 42 x 2 in.)
Collection of the artist

I started to paint. It is probably for the same reason that I shifted to sculpture when I arrived in France. I faced the same kind of problems, the isolation and estrangement. When you do not know the language, you cannot communicate. And if you have something to say, it is bound to come out one way or the other![37]

As a teenager she enrolled in art history classes at university and, having been rejected from the art schools, independently began to paint dark, German expressionist-style canvases. In the early 1990s Poulsen moved to France with her then partner Michel Moglia, a ceramicist and sculptor. It was through his work with clay that she first became interested in the material. One day she picked up a piece of iron and began shaping it. Adding clay and glazes, she soon began to experiment with the materials and learn the properties of the fire.

The results were totemic, elongated figures, with detailed facial expressions and delicately glazed bodies. The expressions of her characters are often the effects of the firing process, which Poulsen respects as a natural part of creation. The cracks on her figures' bodies allow them to acquire a kind of world weariness and wisdom to which all can relate (plate 16, fig. 16). She notes:

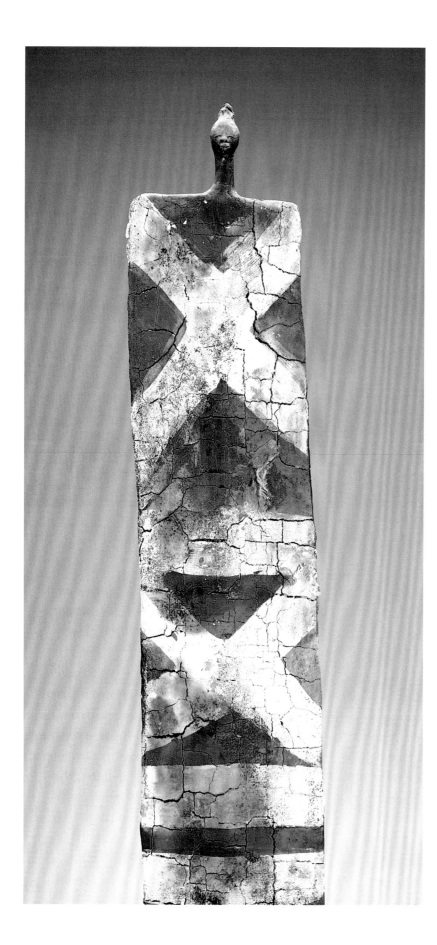

Fig. 16
Etiyé Dimma Poulsen
Homme carré
1998
Ceramic
196 x 18 cm
(77 x 7 in.)
Collection of the artist

In general, fire is my teacher and accomplice. If my sculpture works passed the test of fire, it is as if they are accepted, like in an initiation ritual.[38]

Poulsen does not create portraits, nor is her work autobiographical in any literal way, but it does allow her to give visual form to the difficult experiences of diaspora and negotiations of artistic and personal identity in a cosmopolitan era. Her works are produced in two sizes, those that tower over six feet and those that sit at less than three feet high on podiums (plate 17). While she does not work in series, her personages are often exhibited and also inhabit her studio in groups, as though taking part in ceremony or engaging in a sense of community (plate 18).

In 2002 Poulsen returned to Ethiopia for the first time in many years on a fellowship sponsored by Alliance Française to work with traditional potters—women with great knowledge of firing techniques and the richness of the ceramic medium. These potters are often alienated or ostracized from the greater society, which fears their powers with fire and associates them with the workings of the "evil eye." Poulsen thrived within this community, producing new works that drew from tradition-based forms, gaining a greater insight to the relationships between her practices and those of Ethiopia.

The practice of photography has a long and illustrious history in the art of diasporic African artists. One has only to think of James van der Zee or Chester Higgins and Gordon Parks to understand the power that the photograph has had in the last century in shaping African-American views of self and place within the larger American society. Of course, this quintessential modernist medium also has a darker history in the hands of colonial photographers who aimed the camera lens like a gun, attempting to "capture" and control understandings of cultures and peoples through the supposed "truths" of the photograph.

The works of the youngest artist within this exhibition, **Aida Muluneh**, engage with this conflicted history to present reality "as it is in its rawest sense," recognizing the power of the camera not only to document but to give agency to the people upon whom it focuses. Aida graduated from Howard University in 2001 with a degree from the Department of Film and Communications, working under Abiyi Ford and well-known Ethiopian filmmaker Haile Gerima.

In *Grace* (plate 19) and *Spirit of Sisterhood* (plate 20), Aida draws our attention to women of the diaspora, emphasizing the links and disjunctures between generations, commemorating the sorrows and celebrating the victories in their lives. Her subjects convey graceful yet strong approaches to the challenges of life.

In the last several years, Aida Muluneh has begun to experiment with Polaroid emulsion transfers, creating intimate, riveting portraits of communities and individuals. In this series, she reinserts the physicality of the artist's hand back into the photographic process, meticulously transferring the precarious emulsions to various surfaces and rearranging them into collages of color and texture (plate 21, fig. 17). She sees these Polaroids as paintings that she can "piece together into a completely different story from what [I] initially shot."[39] She says of her emulsions,

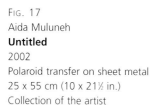

FIG. 17
Aida Muluneh
Untitled
2002
Polaroid transfer on sheet metal
25 x 55 cm (10 x 21½ in.)
Collection of the artist

They may say more about me as a person than the black and white works. I think they probably have a lot to do with my inner self. I find that working so closely with the emulsions, in their placement, selection, surface for transference, I am involved in a harder process, but something that gives me peace.[40]

In *Dues* (fig. 18), Aida pays homage to the strong women who raised her, incorporating images of young and old within a montage of emulsions to suggest the intergenerational bonds at work in the diaspora.

In his *Reflections on Exile*, Edward Said writes:

Exile is strangely compelling to think about but terrible to experience. It is the unhealable rift forced between a human being and a native place, between the self and its true home: its essential sadness can never be surmounted. And while it is true that literature and history contain heroic, romantic, glorious, even triumphant episodes in an exile's life, these are no more than efforts meant to overcome the crippling sorrow of estrangement. The achievements of exile are permanently undermined by the loss of something left behind forever.[41]

Although the experience of exile may bring a sense of loss and nostalgia, it also can provide a certain level of freedom as one sees every place as foreign. One is released from the constraints of tradition, able often to gain a greater sense of self and artistic vision with knowledge of multiple cultures, histories and realities. Modern history has been, to a large extent, shaped by the works of those who have obtained a clarity and maturity of vision that comes with the cosmopolitan experiences of exile. The artistic pursuits of individuals as diverse in their media and contexts as Wosene Kosrof, Mickaël Bethe-Selassié or Achamyeleh Debela are evidence of the fruits of exile.

In his paintings and mixed media works, **Wosene Kosrof** draws upon Ethiopian graphic systems, liturgical symbols, architectural forms and pan-African motifs to produce richly colored and detailed canvases within which the traditional scripts and motifs are freed from their conventions and, like jazz riffs, result in engaging improvisations.

After receiving a degree at the School of Fine Arts in Addis Ababa, Wosene moved to the United States in the late 1970s to attend the MFA program at Howard University where he studied with Jeff Donaldson among others, and learned, informally, from the example and talents of Skunder Boghossian. It was while he was at Howard that he began to explore, in earnest, the richness of the script systems in Ethiopia, searching for an artistic vocabulary he could call his own. During the time Wosene was at Howard, a number of students were

working from the example set by Skunder. It was important to distance himself from the magnetism of Skunder, whose similar engagements with Ethiopian motifs had resulted in insightful, complex works. Wosene found his independence and succeeded in creating a distinctive visual vocabulary that has afforded him a successful career. He speaks to the importance of the magic scroll in his works:

> Early on, I used the shape of the scroll, as background, perhaps even to guard me when I worked. This was fundamental to my identity as an Ethiopian and an Ethiopian artist. Once I was secure there, I began to do the work of visually exploring the magic scroll. That meant that I could cut it up, that is, I dismantled the Amharic symbols, as we know them. Not only was I not using them in words, I was destroying them—and rebuilding them to create a whole new way of seeing them. I was isolating them, taking them off the traditional parchment scrolls, to see them away from their traditional background and to show them to be the monumental figures that they are. They speak then not only to the Ethiopian, but they can now become the healing scrolls for all of us.[42]

Wosene has divided his work into three major series: *Graffiti Magic*, *Africa: The New Alphabet* and *The Color of Words*. In the first, the language symbols act as forms of visual protest; in the second, they become a form of visual poetry. By distorting, manipulating and elongating Ge'ez symbols he disassociates them from traditional or conventional forms and breathes new graphic life into them. They act as floating signifiers.

> The beauty of the letters, their elegance, their sensuality, enable me to explore them and see them in all their different postures and poses. They are living beings for me and they represent all living things I sense around me.[43]

In the third and current stage, Wosene morphs the Ge'ez characters into pure abstraction, thus creating his own visual language. He speaks to his recent works as investigations into a new alphabet, one which cleverly employs a vocabulary of signs and symbols to link past with present, and Africa with the diaspora.

In *The Preacher III* (plate 22), Wosene envisions the preacher as someone who promotes human rights. This artwork is not about preaching in a literal or religious sense, but about the efforts people can make to shape culture and improve the human condition. In this and other works, Wosene abstracts linguistic characters from the Amharic language. In *My Ethiopia* (plate 23) the script becomes abstract design and the characters are free to scroll across the canvas horizontally rather than vertically. Letters in this painting also carry literal meaning, such as culture, society, unity and education.

While his works clearly benefit from and pay homage to long-standing artistic traditions, his experiences within the diaspora and his engagement with many art

Fig. 18
Aida Muluneh
Dues
2002
Polaroid transfer on plexiglass, wood-framed lightbox
136 x 30.5 x 17 cm
(54 x 12 x 7 in.)
Collection of the artist

histories and audiences have allowed Wosene to imagine Ethiopia in a highly personalized way. With the smaller squares making up *The Color of Words IV* (plate 24), he makes reference to traditional Ethiopian icon paintings. Unlike traditional forms, though, these are filled with writing rather than religious iconography. Wosene's concern is language and the abstracted symbols are intended as a form of visual poetry; thus, the letters become voices addressing a diverse global audience.

His *Wax and Gold IX* (fig. 19) mixed media work refers to a characteristic of Amharic poetry. The phrase "wax and gold" refers to the actual process of casting gold in wax molds and traditional Ethiopian verse that carries dual meanings, one more apparent than the other. In this painting, the black and white provide a clear contrast like that between wax and gold. On a more subtle level, the gold is the visual presence of the language characters without any literal meaning.

Fig. 19
Wosene Kosrof
Wax and Gold IX
2002
Mixed media
46 x 46 cm
(18 x 18 in.)
Collection of Matt and
Shanette Westphal

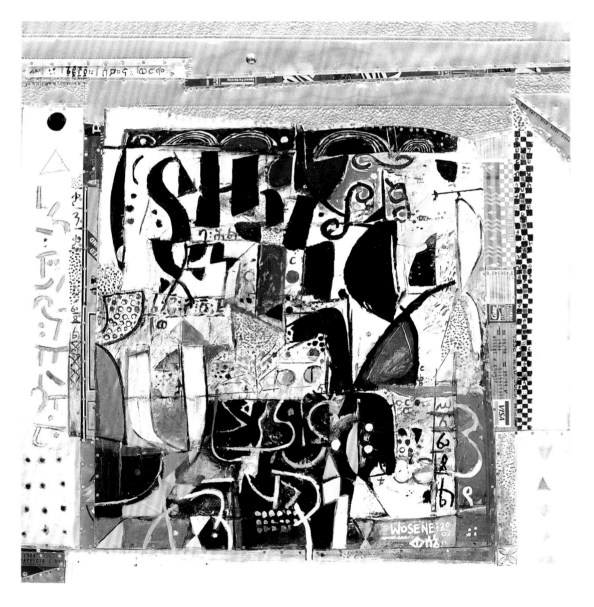

Like Wosene Kosrof, **Mickaël Bethe-Selassié's** experiences of exile have borne remarkable fruits. Born in 1951 in Ethiopia, Mickaël attended the French lycée in Addis Ababa before moving, at the age of 20, to pursue higher education in France. He has remained there ever since. He writes of his journey from home:

I left Ethiopia in 1971. The revolution happened three years later, in 1974. When I left, the country was full of prosperity, the nobility was at its apogee and everyone, whether it was de Gaulle, Pompidou or Queen Elizabeth was falling on their knees in front of the Emperor. The regime fell because it didn't pay attention to the people. I left Ethiopia to go follow higher education in France. But I discovered that the sciences didn't suit me. In the meantime there was revolution in my country. I found myself no longer a student, but in exile. After five years of searching, I found my own way, that which I called my way, painting, sculpture, yoga, and zen. During those years in exile I felt the need to return to Ethiopia but I waited until there was a new change in the regime.[44]

Mickaël is self taught, discovering his passion and talent for sculpting and painting through a home design project. He created a multicolored screen to block views into his open kitchen and continued to experiment from there. He was drawn to papier mâché not only because of the tactility, lightness and malleability of the material but also its ability to hold paint colors well. During a period of self-reflection, when he became involved with yoga, sensitive to environmental causes and in tune with his spirituality, he linked the crisis of drought and famine in Ethiopia with his practice. The artist considered his use of papier mâché as a means of replenishing, if not literally, then figuratively, his parched homeland.

Mickaël sees his practice as global in nature and draws inspiration for his painted sculptures not only from the church paintings of Ethiopia but from the masks of the world's carnivals and the artistic and daily lived experiences of over 20 years in Europe. He does not see himself as belonging to a community of Ethiopian diaspora artists, as there are so few in France, but as noted above, the fall of the military regime has allowed him to return to his home and see it in a new way, with the eyes of a seasoned exile.

Above all, the artist is a masterful colorist. He says he cannot imagine a sculpture without paint. In a sense it is naked. With the paint he can "animate it and give it a sort of narrative character."[45]

Works such as *Fantasia* (plate 25, fig. 20) and *Mégalithe* (plate 26) showcase Mickaël's artistic genius. Through their colossal size and bold coloring, the works convey a presence that is at once playful and commanding. Mickaël does not work from sketches or models but rather creates these fantastic characters in an improvisational manner, applying layers of thickly textured paper over chicken wire and wooden frames.

In *Voyage Initiatique* (plate 27), the artist enlivens an elegant, playful structure of two figures embarking on a journey of exploration with strong hues of red, purple and orange. The title refers to adolescent initiation rites that mark passage into adulthood. At the same time, this transition suggests geographic displacement, as many young people, like the artist before them, move between rural and urban environments, cross national and international

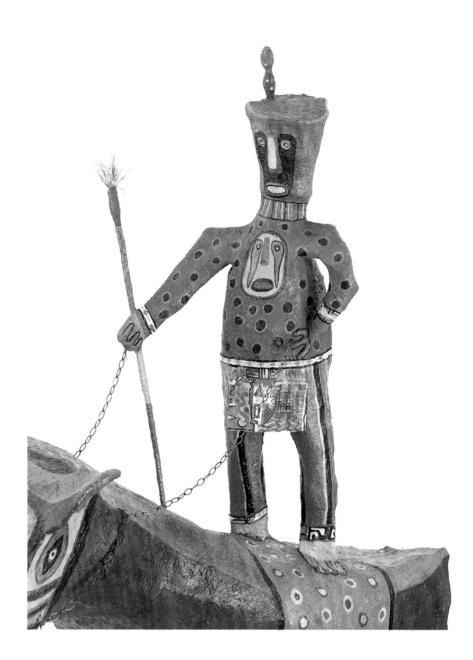

Fig. 20
Mickaël Bethe-Selassié
Fantasia (detail)
1994
Papier mâché and polychrome
on wood and cane
230 x 195 x 110 cm
(90½ x 77 x 43 in.)
Collection of the artist

borders and embark on both psychic and physical journeys from home. *Voyage Initiatique,*
then, has a dual implication, invoking elements of traditional heritage as well as contemporary
transnational experience.

Mickaël's experiences with multiple cultures, art worlds and histories have afforded him a
plurality of vision, a freedom from convention and an awareness of self that has allowed his
marvelous, carnivalesque oeuvre to blossom.

Achamyeleh Debela's distance from home, combined with the democratizing effects of
digital technology, have created a lively experimental space within which the artist is able to
play with motifs and compositions from Ethiopian liturgical arts as well as pan-African symbols

FIG. 21
Achamyeleh Debela
The Priest
1990–91
Digital image cibachrome print
40.5 x 50.8 cm (16 x 20 in.)
Collection of the artist

(plate 28). Referring to his work as "computer assisted," Achamyeleh continues to work as a painter and clearly transfers his experiences of its formal attributes to the digital medium.

> *I bring to the computer canvas a variety of ideas, some that I have resolved via painting using traditional tools, such as acrylic on canvas or any number of mixed media, photographs, three dimensional images created in the computer world, drawings, sketches, etc. These sources are selected, digitized or scanned and are made available*

as data and I have access to as many or as few of these resources at a time where I selectively use portions of colors here, figures there or surface textures and decorations here and compose my visual music.[46]

Currently a professor of art and computer graphics at North Carolina Central University, Achamyeleh received a diploma in fine arts in 1967 at the School of Fine Arts in Addis Ababa, working closely with Gebre Kristos Desta among others. He has multiple degrees in art history and fine arts, culminating in a doctorate in digital technology from Ohio State University, the institution where he first encountered the computer as an artistic tool. Since that time, he has been engaged in a concentrated effort to expand the parameters of contemporary visual arts to include the powerful aesthetic of computer-assisted arts, what he calls "digital paintings." As colleague and friend Raymond Silverman notes: "Today, one seldom sees Achamyeleh without his digital camera; it has become an appendage, allowing him to constantly record his experiences, collecting images that he may draw upon for future 'digital paintings.'"[47]

Achamyeleh's iconography can be pan-African in nature and his references are broad ranging. Motifs fade in and out of focus in his digital collages such as *Song for Africa* (plate 29), in which the artist maintains the compositional framework of traditional paintings, utilizing a series of horizontal registers and richly decorated borders. The technology also allows him to play with perspective and saturate color. Achamyeleh's focus on strong, well-known pan-African forms, like the ankh, speaks to the potency of visual symbols as markers of identity in the diaspora.

In *Spirit at the Door* (plate 30), the artist superimposes an Asante brass head upon a Dogon granary door to create a ghostly image that fills the picture frame as though seeking to burst into three-dimensional reality. Again, digital technology has enabled Achamyeleh to play masterfully with perspective and has freed him from some of the limits of conventional media.

The church artist in Ethiopia was responsible for illuminating scrolls and manuscripts, creating a means through which the faithful could access the teachings of the Bible. There are also individuals known as *debteras* who make written charms, especially magic scrolls, and have great knowledge of plants, astrology and the spirit world in general. These magic scrolls are designed to offer protection from demons and the evil eye and healing for the sick. Achamyeleh's *The Priest* (fig. 21) calls to mind both sets of traditions. In this composition, the priest strikes a rather arresting and secretive pose. He is swathed in a multicolored mosaic head wrap that covers his face, except for his nose and one ear, as though enveloped or held captive by the patterns of his artistic creations.

POSTSCRIPT

"It ain't where you're from it's where you're at . . ."[48]

We began our exploration of diaspora with an understanding of the malleable and shifting nature of its parameters. It is the museum's hope that our audience's experiences with the

works of these 10 artists will lead to a deeper understanding of the transformative powers that diasporic life may have upon the creative process. However, it is also our goal to demonstrate that each artist engages with the implications of diaspora individually, in light of his or her own experiences and artistic sensibilities.

Ultimately, the artistic visions, the playful, even bold experimentation with materials and techniques, and the rich iconography in all of their works are the results of ongoing, personal mediations of artistry within the contemporary global art scene, rather than affiliations to a narrowly defined realm of identity.

ENDNOTES

1 Salman Rushdie, *Imaginary Homelands 1981–1990: Essays and Criticism* (New York: Viking, 1991).

2 James Clifford, "Diasporas," *Cultural Anthropology* 9 (3) (1994): 302–38.

3 Ibid., 306.

4 Homi Bhabha, *A Measure of Dwelling: A History of the Invisible Hand* (Cambridge, Mass.: Harvard University Press, forthcoming).

5 George Lamming, *Pleasures of Exile* (London: M. Joseph, 1960).

6 The Middle Passage refers to the middle portion of a three-part voyage in which ships transported cargo between Europe, Africa and the Americas. On the trip from Europe to Africa, ships were loaded with cargo such as iron, cloth, brandy and firearms. Upon arrival in African ports, the goods were unloaded and exchanged for human cargo. During the second leg of the trade route—the Middle Passage—people from along Africa's "slave coast" were transported en masse to the Americas, where they were sold into slavery. In the Americas the ships were reloaded with sugar, tobacco and other products for the return to Europe.

7 Paul Gilroy, *The Black Atlantic: Modernity and Double Consciousness* (London: Verso, 1993).

8 David W. Haines, ed., *Case Studies in Diversity: Refugees in America in the 1990s* (Westport, Conn. and London: Praeger, 1997), 265

9 Sanford J. Ungar, *Fresh Blood: The New American Immigrants* (New York: Simon and Shuster, 1995): 255.

10 The largest groups are the Abyssinians, Eritreans, Tigreans and Oromo. While Christianity has an ancient history in the region, many Eritreans are Muslims.

11 Elizabeth Biasio, *The Hidden Reality: Three Contemporary Artists*, 25.

12 Solomon Deressa, "Skunder in Context" in *Ethiopian Bir* (January/February, 1997): 15–16.

13 Afewerk Tekle studied at the Slade School of Fine Art in London (1947). His work was characterized by academic realism with some elongation of the figures for dramatic effect. He has served as cultural advisor under Haile Selassie, Mengistu Haile Mariam and Meles Zenawi.

14 Deressa, "Skunder in Context," 14.

15 Stanislaus S. Chojnacki, "Skunder: His First Addis Ababa Exhibition," *Ethiopia Observer* X/3 (1966): 184.

16 Wendy Kindred, "Skunder and Modern Ethiopian Art" in *Aspects of Ethiopian Art*, ed. Paul Henze (London: Jed Press: 1993), 133.

17 Other Ethiopian artists who passed through the Department of Fine Arts at Howard University who are not included in this exhibition are Tesfaye Tessema, Alemayehu G. Mehdin, Falaka Armide, Sophia Kiflé, and Falaka Yimer.

18 Sydney W. Head "A Conversation with Gebre Kristos Desta," *African Arts* 2 (4) Summer 1969.

19 Ibid., 52.

20 A number of artists remained active in Ethiopia during the rule of the Derg, most notably Worku Goshu and Zerihun Yetmgeta, and the arts school stayed open, teaching in the conventions of a social realist style. A number of artists at work today were trained in this genre and followed journeys of their own to study and work in the former Eastern Bloc nations (Poland, East Germany) and Russia. See Achamyeleh Debela's essay in this volume for a discussion of Prop-Art.

21　Elizabeth Habte Wold returned to Ethiopia in the late 1990s, as did Yohannes Gedamu, a painter who worked for many years in Germany.

22　"Entretien avec Mickaël Bethe-Selassié" by Maithé Valles-Bled in *Mickaël Bethe-Selassié: Sculptures* (Chartres, France: Musée des Beaux-Arts, 1995), 19.

23　Frank Sirmans, "Mapping a New, and Urgent, History of the World," *New York Times*, Arts and Leisure section (2001), 2.

24　Julie Mehretu, press release, Walker Art Center, Minneapolis, 2002.

25　Edward Soja, "Introduction" in *Third Space: Journeys to Los Angeles and Other Real and Imagined Places* (London: Blackwell Press, 1996), 1.

26　Kebedech participated in the youth league of the Ethiopian Peoples Revolutionary Party (EPRP), one of the larger, more established opposition groups that contained a lot of student members. Somalian fighters engaged in the Ethio-Somalian border conflict caught her.

27　Kebedech Tekleab, "A Long Walk in the Light of Art," artist statement, 2002, 4.

28　Ibid.

29　Kebedech refers to Goya's famous masterwork of 1814 entitled *The 3rd of May 1808 in Madrid: The Executions on Principe Pio Hill*, housed in the Prado Museum of Art in Madrid. Telling of the infamous executions of Spanish patriots by Napoleon's forces, this painting has come to represent not only one of the best-known images of raw patriotism but also of the tragedies of war and the defiance of its participants.

30　Kebedech Tekleab, "A Long Walk in the Light of Art."

31　In 2001, Kebedech Tekleab and Alexander "Skunder" Boghossian collaborated on an important sculptural commission at the new Ethiopian Embassy in Washington, D.C. The work produced there, through computer and industrial arts technology, brought together in one stunning work the symbols, iconography, palette, and stories of all of Ethiopia's peoples. The marriage between Skunder's catholic approach to visual heritage and Kebedech's sensitivity towards ethnic strife and representation was extremely fruitful. According to Kebedech, *Nexus* represents the historical, spiritual and cultural bearing of the Ethiopian people. . . . The artwork includes themes from Christian, Islam, Judaic and other indigenous spiritual practices such as the Sheik Hussein spirituals, and the Oromo "Oda." The symbolic scrolls contain major historic forms from Axumite architecture and other sculptures and monuments referring to the kingdom of Axum, Gondar and Lalibela. The scrolls also include shapes of musical instruments and other utilitarian tools that are representative of the daily life of the common people. Forms of flora and fauna are also included to suggest the respective topography of the highlanders and lowlanders.

32　Deressa, "Skunder in Context," 27.

33　Ibid., 20.

34　There have been numerous writings on the development of Skunder Boghossian's career. I am not able in this forum to trace the career of this master in depth—that should accompany a retrospective exhibition—however, the best of these writings can provide a good overview. See Solomon Deressa, "Skunder in Context" in *Ethiopian Bir* (January/February 1997): 14–28.

35　Deressa, "Skunder in Context," 27.

36　Salah Hassan, "Magical Realism: Art as Ritual in the Work of Elsbeth Tariqua Atnafu" in *NKA: Journal of Contemporary African Art* (Fall/Winter 1996): 26.

37　Florence Alexis and Salah Hassan, "Creativity and the Hybrid Subject: Etiyé Dimma Poulsen, the Artist in Her Own Words" in *Gendered Visions*: *The Art of Contemporary Women Artists* (Trenton, N.J.: Africa World Press, 1977), 58.

38　Ibid., 60.

39　Aida Muluneh, correspondence with author, December 2002.

40　Ibid.

41　Edward Said, *Reflections on Exile* (Cambridge, Mass.: Harvard University Press, 1992), 173.

42　Wosene Kosrof, *Personal Statement* (2002): 2.

43　Wosene Kosrof: 1.

44　"Entretien avec Mickaël Bethe-Selassié": 19.

45　Ibid., 18.

46　Achamyeleh Debela, "Digitally Speaking" (2002).

47　Raymond Silverman, "Digital Art, Digital Painting" (Addis Ababa: Asni Gallery, December 2001), 5.

48　Rakim (W. Griffin), *The Ghetto*, as quoted in Paul Gilroy, "It Ain't Where You're From, It's Where You're At. . . . The Dialectics of Diasporic Identification" in *Third Text* 13: 3–16, 1991.

Artist Biographies and Plates

Julie Mehretu

Kebedech Tekleab

Elizabeth Habte Wold

Alexander "Skunder" Boghossian

Elisabeth Atnafu

Etiyé Dimma Poulsen

Aida Muluneh

Wosene Kosrof

Mickaël Bethe-Selassié

Achamyeleh Debela

Julie Mehretu
b. 1970, Ethiopia

After studying in Senegal, Mehretu received her BFA from Kalamazoo College and MFA from the Rhode Island School of Design. She completed a residential fellowship at the Museum of Fine Arts in Houston in 1998–99, and her work appeared in several exhibitions in the Houston area. After completing the fellowship, Mehretu relocated to New York City where she has lived and worked since.

The recipient of many awards, Mehretu's work was the subject of solo exhibitions at the Walker Art Center in Minneapolis (2002), The Project and Art Pace in New York (2001), as well as other galleries. In addition, her work has been included in exhibitions in Belgium, Mexico and the United States, notably the Studio Museum of Harlem and P.S. 1 Contemporary Arts Center in New York.

Mehretu's powerful compositions combine techniques of painting and drawing as they invoke a sense of space, place and movement. Her work has been influenced by the diverse architectural forms in places she has called home—Ethiopia, Michigan, Texas, New York. The variety of forms and media employed suggest multiple layers of materials, time and experience, both fixed and mobile.

PLATE 1
Untitled
2001
Ink and acrylic on canvas
152.5 x 213.5 cm (60 x 84 in.)
Private collection (courtesy White Cube, London)

PLATE 3
Implosion/Explosion
2001
India ink
Site-specific installation, Studio Museum, New York

PLATE 2
Dispersion
2002
Ink and acrylic on canvas
Collection of Nicholas and Jeanne Greenberg, Rohatyn, New York

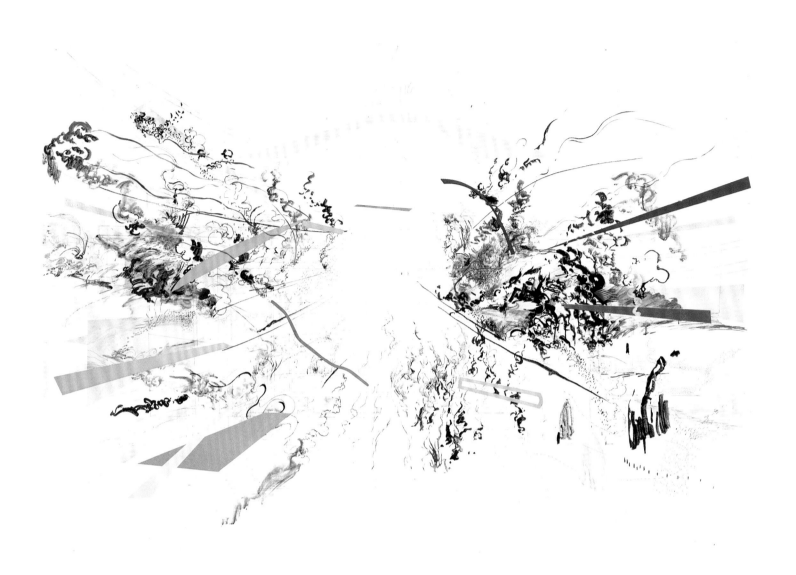

Plate 1

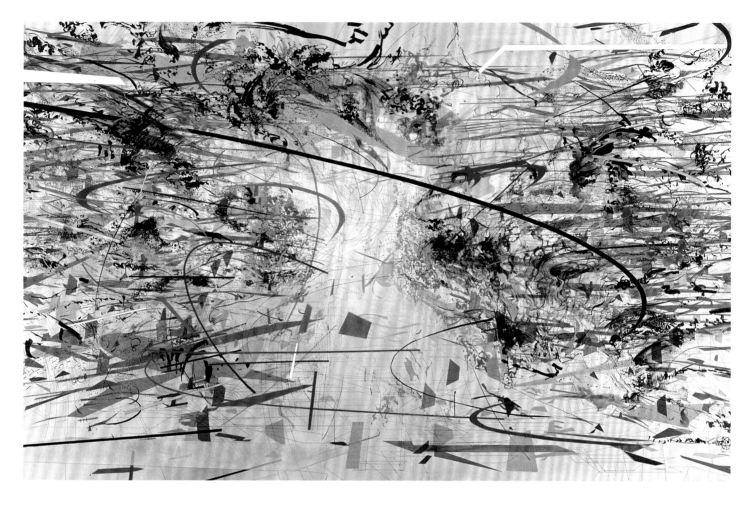

PLATE 2

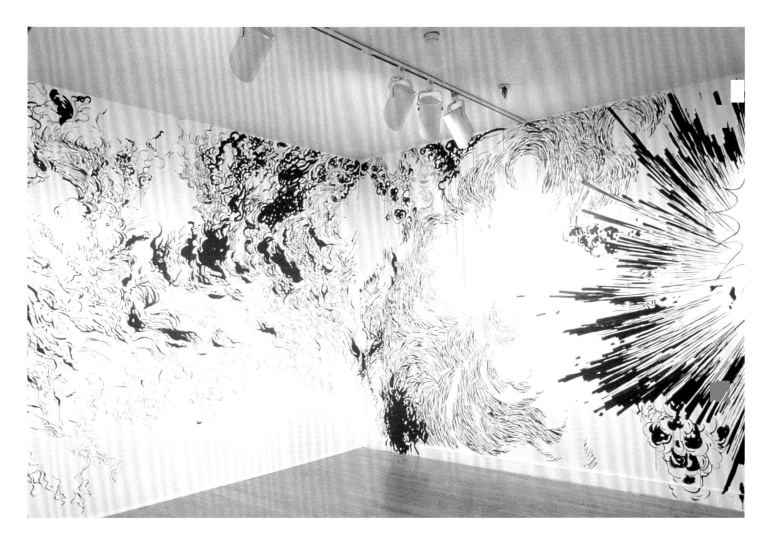

Plate 3

Kebedech Tekleab
b. 1958, Ethiopia

A poet and visual artist, Kebedech attended the School of Fine Arts in Addis Ababa. During the revolution in the late 1970s, she became active in the student resistance movement. As Kebedech fled the Ethiopian regime, she was taken prisoner in the Ethiopian-Somali conflict and imprisoned in a labor camp for nearly a decade. Following her release in 1988, Kebedech joined family members exiled in the United States. She attended Howard University, where she received her BFA in 1992 and MFA in 1995. The artist has lived, worked and taught in the Washington, D.C. area since then. Kebedech's paintings have been featured in several group exhibitions and individual shows throughout the United States.

She recently collaborated with Skunder Boghossian on a commission at the Embassy of Ethiopia in Washington, D.C., and is currently at work on a second project commissioned by the embassy. In addition, Kebedech is associated with the Legacy Project, a nonprofit institution highlighting the work of artists linked by common themes of past tragedies, including war, genocide, ethnic conflict and population displacement. The Legacy Project was created to explore and foster a new global dialogue based on the common language of society's shared inheritance of loss, and Kebedech takes part in this global creative dialogue.

PLATE 4
Shackled
1993
Acrylic on canvas
137 x 214.5 cm (54 x 84½ in.)
Collection of the artist

PLATE 6
Behind the Bars I
1994
Acrylic and modeling paste on canvas
50.5 x 61 cm (20 x 24 in.)
Collection of the artist

PLATE 5
The River in Rwanda
1994
Acrylic on canvas
173 x 71.5 cm (68 x 28 in.)
Collection of the artist

Plate 4

PLATE 5

Plate 6

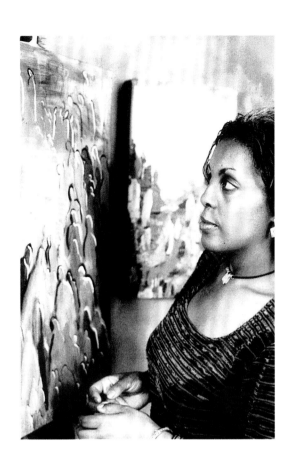

Elizabeth Habte Wold
b. 1966, Ethiopia

Elizabeth Habte Wold completed degrees in fine arts and graphic design at the School of Fine Arts in Addis Ababa, Ethiopia, and Baltimore City Community College in Maryland before continuing on to an MFA at Howard University. She also completed a certificate program in interactive multimedia and web design at George Washington University, where she developed a long-standing interest in digital media. Since the mid-1990s Wold has worked as a multimedia designer and recently returned to live in Addis Ababa.

Wold's interests and training in fine arts, graphic design and technology are apparent in her recent work with collage, in which she creates strong compositions integrating elements of mass media. Through this medium, Wold synthesizes her own transnational experience and explores wider questions of heritage, generations and diaspora.

In the last decade, Wold's work has been featured in several exhibitions in the Washington-Baltimore area, as well as in Ethiopia. In addition, she has collaborated with other Ethiopian artists on mural projects in the Washington area, including the Duke Ellington School for the Arts.

PLATE 7
Lonely Mother
1993
Mixed media collage and graphite on paper
38.5 x 28.5 cm (15³⁄₁₆ x 11¼ in.)
Collection of the artist

PLATE 8
Forgotten Souls I
1993
Mixed media collage and graphite on paper
40 x 57.5 cm (16 x 22½ in.)
Collection of the artist

PLATE 9
The Three Women
1994
Acrylic on canvas
61 x 91.5 cm (24 x 36 in.)
Collection of Berhane Wold

Plate 7

PLATE 8

Plate 9

Alexander "Skunder" Boghossian
b.1937, Ethiopia

In 1954, Skunder won second prize at the Jubilee Anniversary Celebration of Ethiopia's Emperor Haile Selassie I. The next year he was awarded a scholarship to study in Europe and spent two years in London at St. Martin's School, Central School and the Slade School of Fine Art. He extended his sojourn in Europe another nine years as a student and teacher at the Académie de la Grande Chaumière in Paris. In 1966 Skunder returned to Ethiopia and taught at the School of Fine Arts in Addis Ababa until 1969. He made his first trip to the United States in 1970 and has lived here since, teaching at Howard University from 1972 to 2001.

As a practicing artist, Skunder's paintings have been shown in numerous solo and group exhibitions in Ethiopia, the Caribbean, Europe, North and South America. He is also distinguished by being the first contemporary African artist to have work purchased by the Museum of Modern Art in New York.

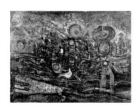

PLATE 10
The End of the Beginning
1972–73
Oil on canvas
122.5 x 170 cm (48 x 67 in.)
National Museum of African Art, museum purchase, 91-18-2

PLATE 11
Time Cycle III
1981
Embossed bark cloth
122 x 122 cm (48 x 48 in.)
Lent by Contemporary African Art Gallery, New York

PLATE 12
Jacob's Ladder
1984
Mixed media on paper
66 x 59 cm (26 x 20 in.)
Lent by Contemporary African Art Gallery, New York

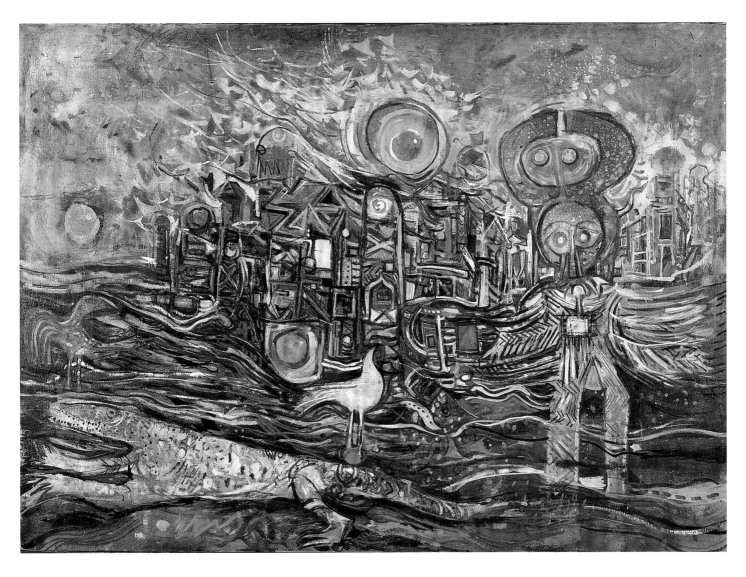

PLATE 10

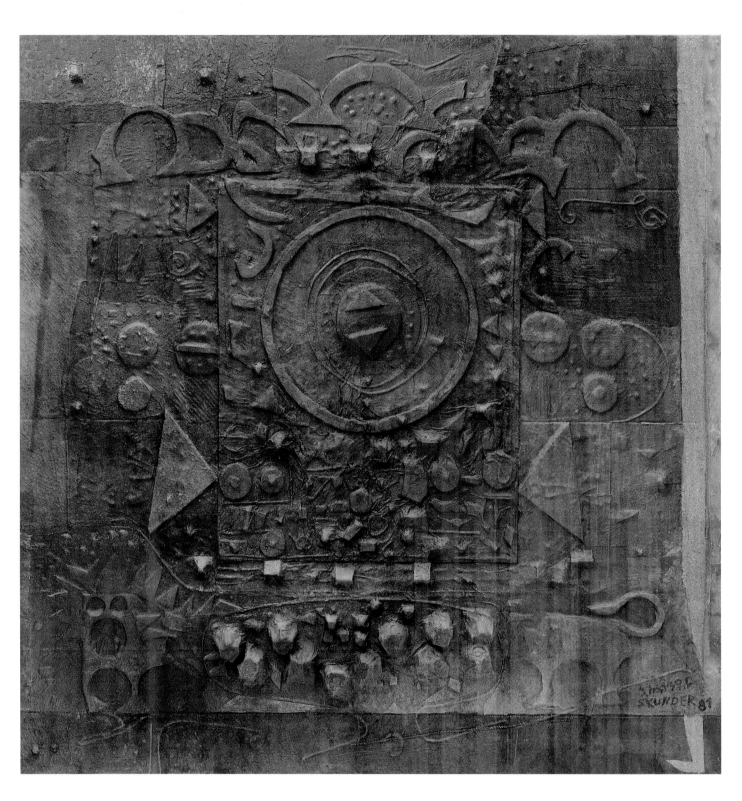

Plate 11

Plate 12

Elisabeth Atnafu
b. 1953, Ethiopia

Elisabeth Atnafu was raised in the highly cosmopolitan environment of Addis Ababa that preceded the fall of Haile Selassie's regime in the 1970s. In Addis Ababa, Atnafu received no formal art training, but had shown ability and interest in art since childhood as one born to an artistically inclined family—her father was a furniture maker and a sister was an art professor at the School of Fine Arts in Addis Ababa.

Atnafu first came to the United States at the age of 14, and later enrolled at Howard University as an art student. There, she completed a BFA in 1975. In the late 1980s, Atnafu maintained a studio in New York and commuted to Washington, D.C., where she worked in Skunder Boghossian's studio. The two explored the history and heritage of their homeland, from which Atnafu had been removed at a relatively early age. Atnafu returned to Howard in 1994 to pursue her MFA. She has continued informal study of African imagery as well as that of Latin American cultures to add a multicultural component to her visual vocabulary. Atnafu's work incorporates her own diasporic experiences as well as those she encountered around her in the pluralism of New York City.

Elisabeth Atnafu has been featured in a number of individual and group exhibitions in Africa, Europe and the United States, and her work is on permanent exhibit at the Paris Museum of Prints and Photography and the Museum of Modern Art in Mexico.

PLATE 13
Haunted Forest
1992
Acrylic on canvas
168 x 203 cm (66 x 80 in.)
Collection of the artist

PLATE 14
Dream Dancers (detail)
1999
Mixed media
Each panel: 52.5 x 25.5 x 3.5 cm
(21 x 10 x 1 in.)
Collection of the artist

PLATE 15
Shrine for Angelica's Dreams
1995–96
Mixed media
200 x 200 x 32 cm
(79 x 79 x 13 in.)
Collection of the artist

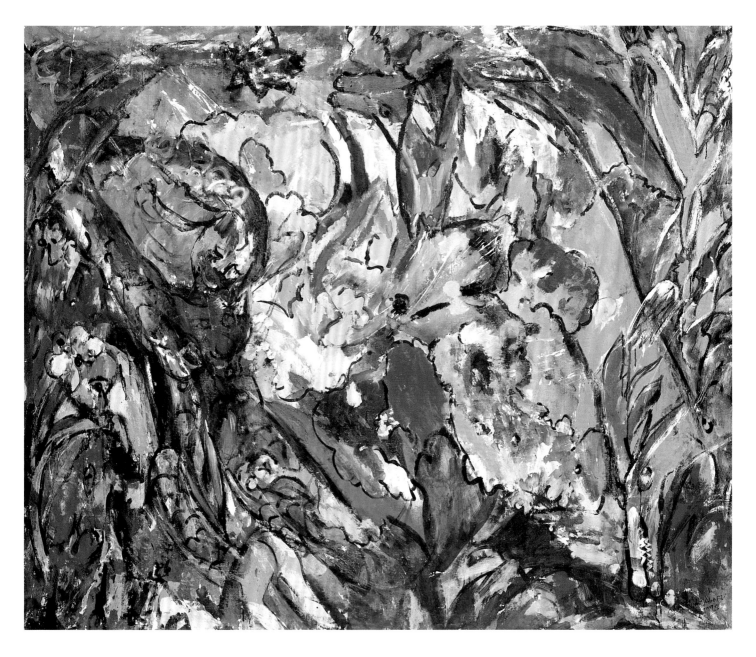

PLATE 13

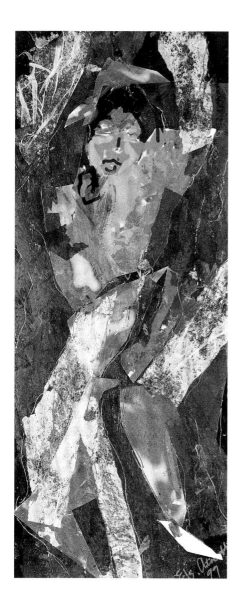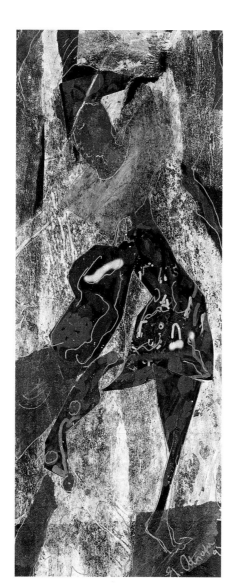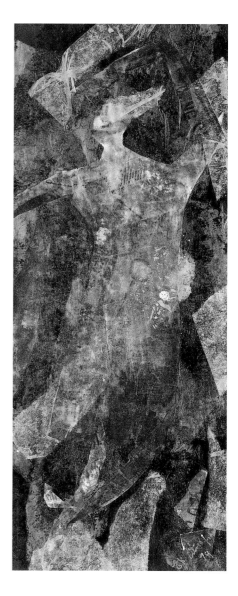

PLATE 14

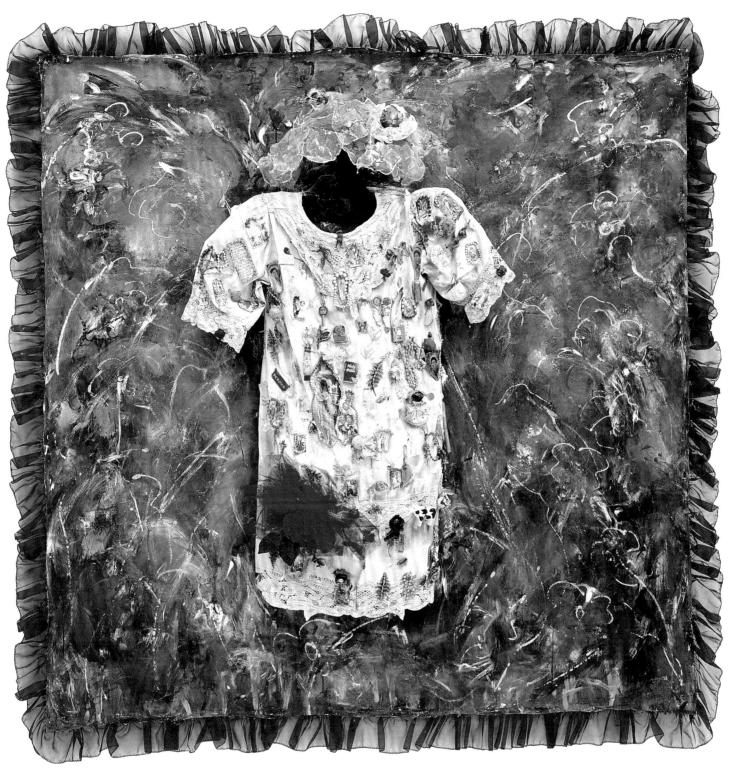

PLATE 15

Etiyé Dimma Poulsen
b. 1968, Ethiopia

Born in Aroussi, a rural community in Ethiopia, Poulsen lived in Ethiopia until the age of six. Following her mother's death, Poulsen was adopted at the age of two by Danish parents and moved with her adoptive family through Ethiopia, Tanzania and Kenya. The family moved to Denmark when Poulsen was 14. She soon began to paint in response to constant relocation and cultural transition, to "remedy the pain of exile, as a means of alleviating the difficulties . . . of adjusting to a new society." Poulsen later studied art history and taught creative arts in youth programs. At the age of 23, she moved to France and soon began working with clay. Poulsen maintains a studio outside of Paris where she lives and works.

By layering clay over iron mesh, Poulsen creates graceful, elongated sculptures. At her studio, she fires each piece in an outdoor kiln of her own construction. Figures emerge with unanticipated features—texture, color, mood. The resulting piece suggests the artist's controlled hand as well as more ambiguous creative forces, each a hybrid of its maker's intention and individual circumstances.

Since she started working with clay, Poulsen's work has been featured in solo exhibitions in Addis Ababa, Dakar and throughout France. Her sculptures have also appeared in several collective exhibitions throughout Europe, Africa and in the United States.

PLATE 16
Matière
1998
Ceramic
45 x 12.5 cm (18 x 5 in.)
Collection of the artist

PLATE 17
Homme carapace
1996
Ceramic
64 x 10 cm (25³⁄₁₆ x 3¹⁵⁄₁₆ in.)
National Museum of African Art, purchased with funds given in honor of Roslyn Adele Walker, 2003-3-2

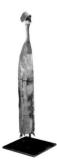

LEFT 18A
Homme en jellabah rouge
2001
Ceramic
56 x 8 cm (22 x 3 in.)
National Museum of African Art, purchased with funds given in honor of Roslyn Adele Walker, 2003-3-1

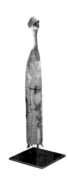

RIGHT 18B
Femme rouge à l'anneau
2001
Ceramic
52 x 14.5 cm (20½ x 6 in.)
National Museum of African Art, purchased with funds given in honor of Roslyn Adele Walker, 2003-3-3

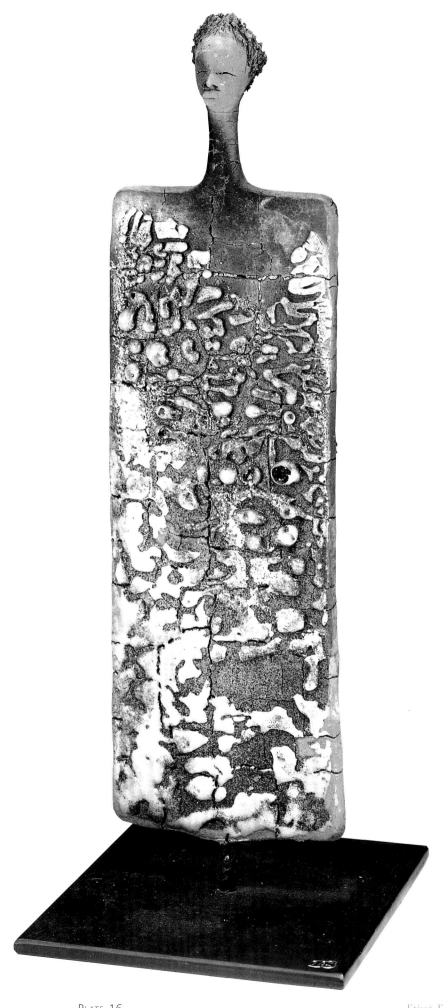

PLATE 16

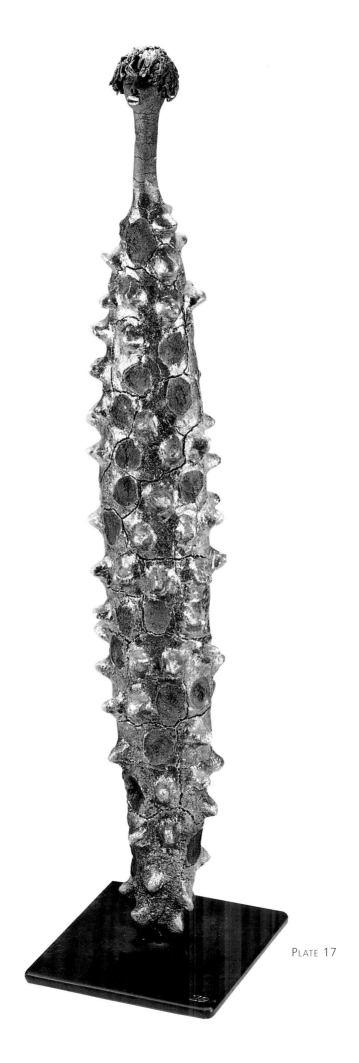

PLATE 17

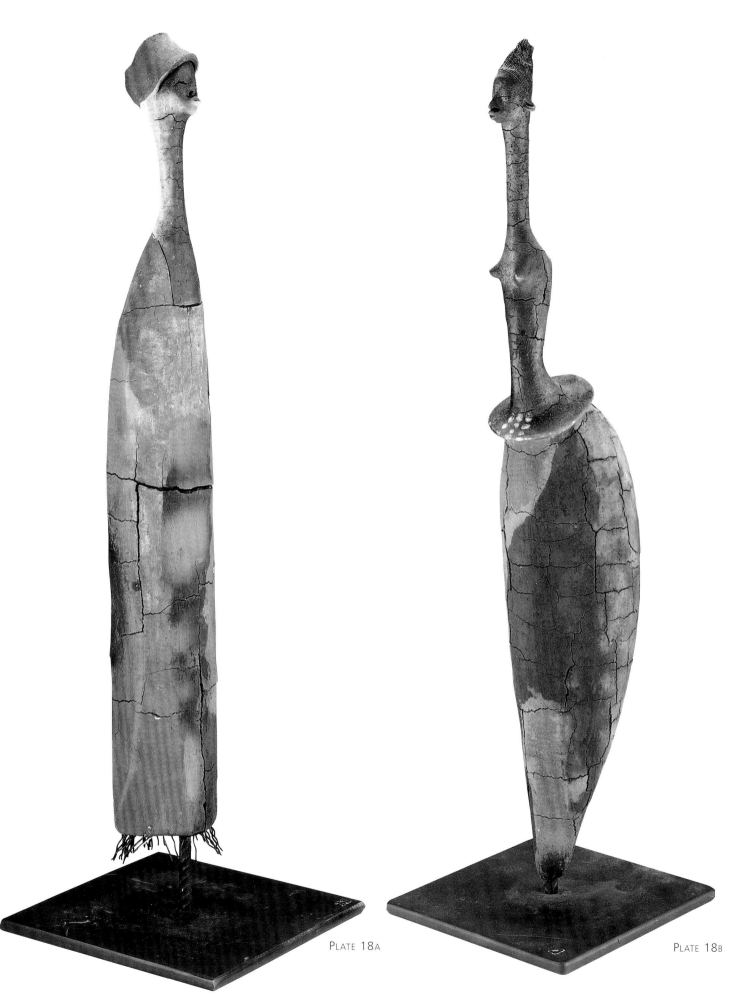

Aida Muluneh
b. 1974, Ethiopia

Born in Addis Ababa, Ethiopia, Aida recalls capturing still images at an early age, though she did not pursue photography systematically until she attended high school in Canada. Aida relocated to the United States to attend Howard University, where she received a BA in film, radio and TV in 2001. Since then, she has worked as a freelance photographer and founded DESTA (Developing and Educating Societies through the Arts), an organization that seeks to develop opportunities in the global community for African artists throughout the diaspora.

As an African woman, artist and activist, Aida hopes her work will serve as a catalyst that will "foster an appreciation for artistic expression among traditional African cultures and assist in changing perceptions about people of color throughout the world." Indeed, her photography and activism demonstrate this conviction.

Aida's photographs have been published in the the *New York Times,* The Source Hip Hop Magazine and U Magazine, among others, and her work has been exhibited in Vancouver and Washington, D.C.

PLATE 19
Grace
1999
Cibachrome print
76 x 101 cm (30 x 40 in.)
Collection of the artist

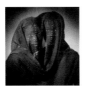

PLATE 20
Spirit of Sisterhood
2000
Cibachrome print
101 x 75.5 cm (40 x 30 in.)
Collection of the artist

PLATE 21A
Foundation
2000
Polaroid transfer on ceramic tile
20 x 20 x 0.5 cm (8 x 8 x ³⁄₁₆ in.)
Collection of the artist

PLATE 21B
Happy
2002
Polaroid transfer on ceramic tile
11 x 11 x 0.3 cm (4 x 4 x ⅛ in.)
Collection of the artist

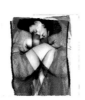

PLATE 21C
The Embrace
2001
Polaroid transfer on ceramic tile
11 x 11 x 0.3 cm (4 x 4 x ⅛ in.)
Collection of the artist

PLATE 21D
Difficult
2002
Polaroid transfer on ceramic tile
11 x 11 x 0.3 cm (4 x 4 x ⅛ in.)
Collection of the artist

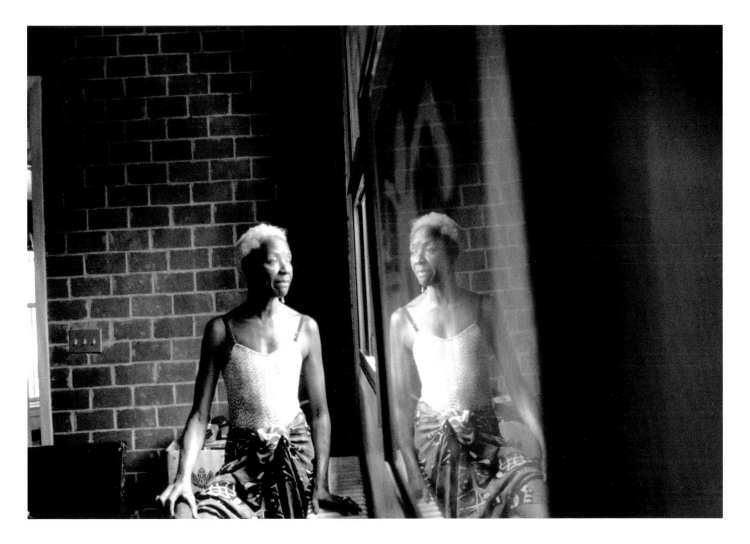

PLATE 19

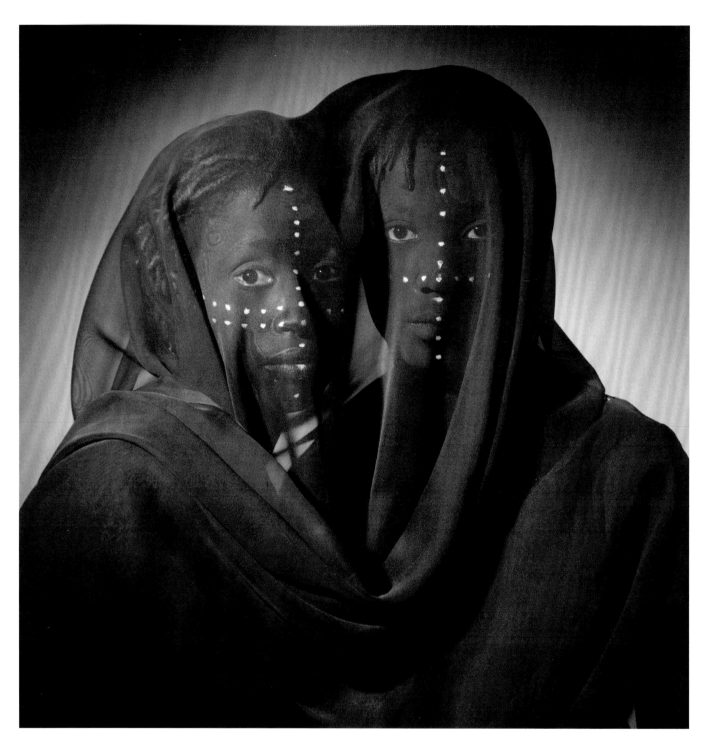

PLATE 20

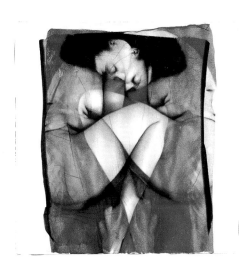

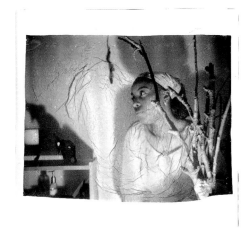

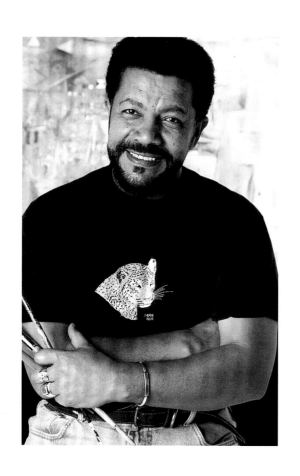

Wosene Kosrof
b. 1950, Ethiopia

Wosene spent his early years in Ethiopia and received a BFA in 1972 from the School of Fine Arts, Addis Ababa. He continued his studies in the United States, where he was awarded an MFA from Howard University in 1980. He taught for a number of years at Vermont College and has participated in a number of international artist workshops and residency programs, most notably the Rockefeller in Bellagio, Italy. Wosene's studio is located in Berkeley, California.

In his vibrant paintings, Wosene draws on the Amharic language, magic scrolls and traditions of poetry, integrating them into his own contemporary experience. The artist emphasizes the importance of jazz rhythms in his work and notes that his visual compositions create spaces in which calligraphic letters can move and dance across the surface of the canvas. From this perspective, music, language and heritage all allow spaces for improvisation.

Wosene has shown his work in solo and group exhibitions in Ethiopia and throughout the United States and Europe. Wosene's paintings were also featured in *Africa '95: Seven Stories about Modern Art in Africa* at the Whitechapel Gallery, London, and his work is found in the collections of the Library of Congress in Washington, D.C., and the Rockefeller Collection in New York.

PLATE 22
The Preacher III
2000
Acrylic on canvas
111.5 x 92 cm (44 x 36 in.)
National Museum of African Art, purchased with funds provided by the Annie Laurie Aitken Endowment, 2001-1-1

PLATE 23
My Ethiopia
2001
Acrylic on linen
132 x 112 cm (52 x 44 in.)
Collection of Marcia and Philip Rothblum

PLATE 24
The Color of Words IV
2001
Acrylic on canvas
96.5 x 99 cm (38 x 39 in.)
Collection of Pat and Jim Stanton

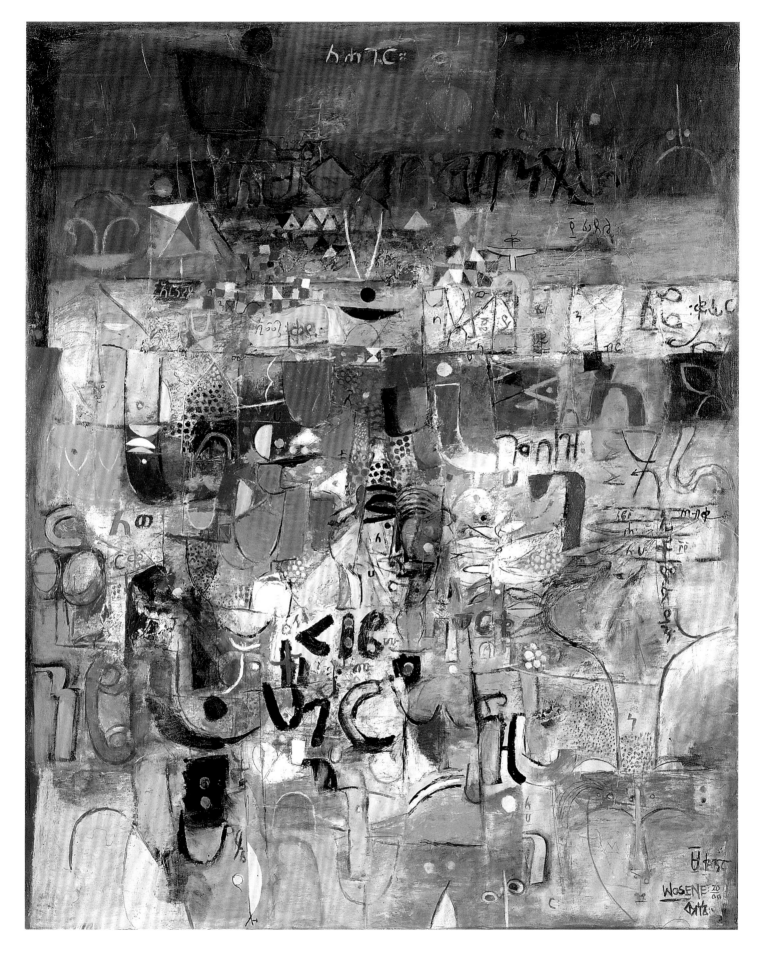

PLATE 22

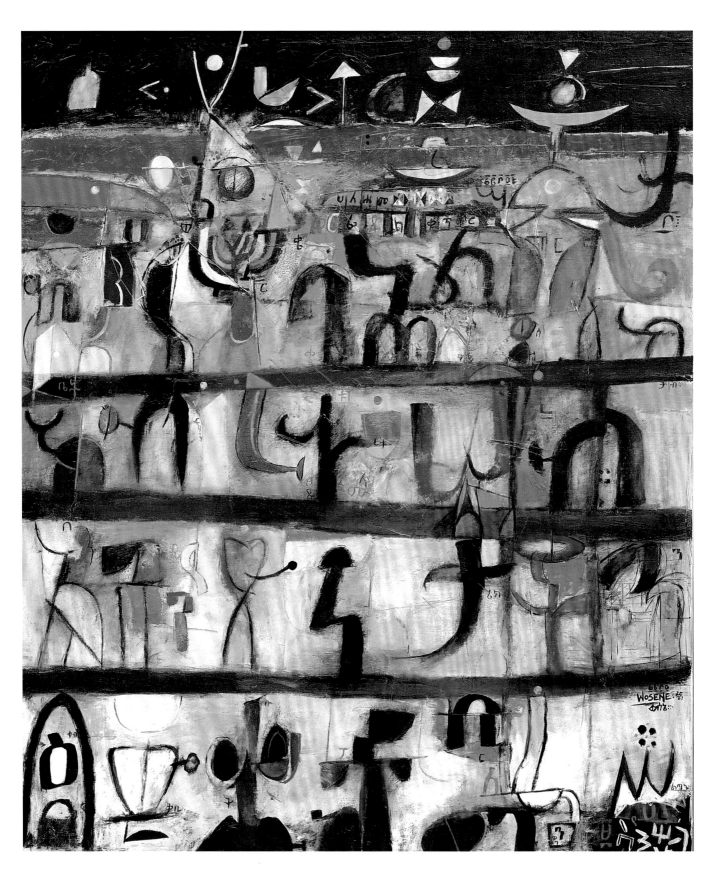

PLATE 23

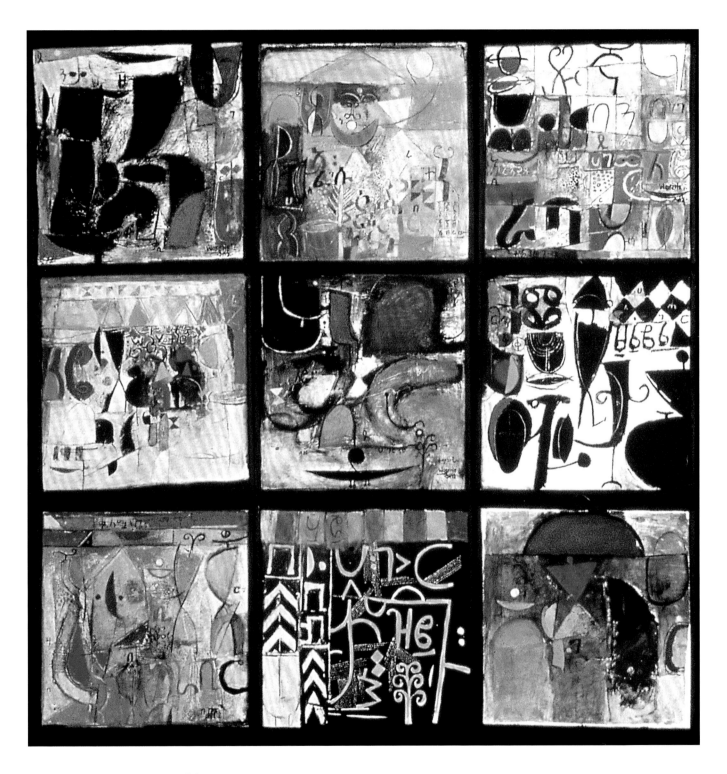

Plate 24

Mickaël Bethe-Selassié
b. 1951, Ethiopia

Following a childhood in Dire Dawa, Ethiopia, Mickaël attended high school in Addis Ababa. After graduating in 1970, Mickaël left Ethiopia for France where he studied the sciences at university. Not until later, at the age of 30, did the self-taught Mickaël begin painting and sculpting in papier mâché. The artist lives and works in Paris.

Mickaël's sculptures are characterized by their imposing size and bold color and each conveys a presence that is at once playful and commanding. The artist's nuanced use of color gives a sense of animation to the figures.

Mickaël's sculptures have been the focus of individual exhibitions in Brazil, Namibia, South Africa and throughout Europe. In addition, his work has been included in numerous group exhibitions throughout the United States and Europe. The artist's work is also included in the city of Paris's contemporary art collection.

PLATE 25
Fantasia
1994
Papier mâché and polychrome on wood and cane
230 x 195 x 110 cm
(91 x 77 x 43 in.)
Collection of the artist

PLATE 26
Mégalithe
1991
Papier mâché and polychrome on wood and cane
310 x 100 x 80 cm
(122 x 39 x 31½ in.)
National Museum of African Art, purchased with funds provided by the Annie Laurie Aitken Endowment, 2003-4-1

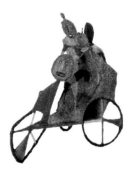

PLATE 27
Voyage Initiatique
1994
Papier mâché and polychrome on wood and cane
163 x 148 x 90 cm
(64 x 58 x 35½ in.)
Collection of the artist

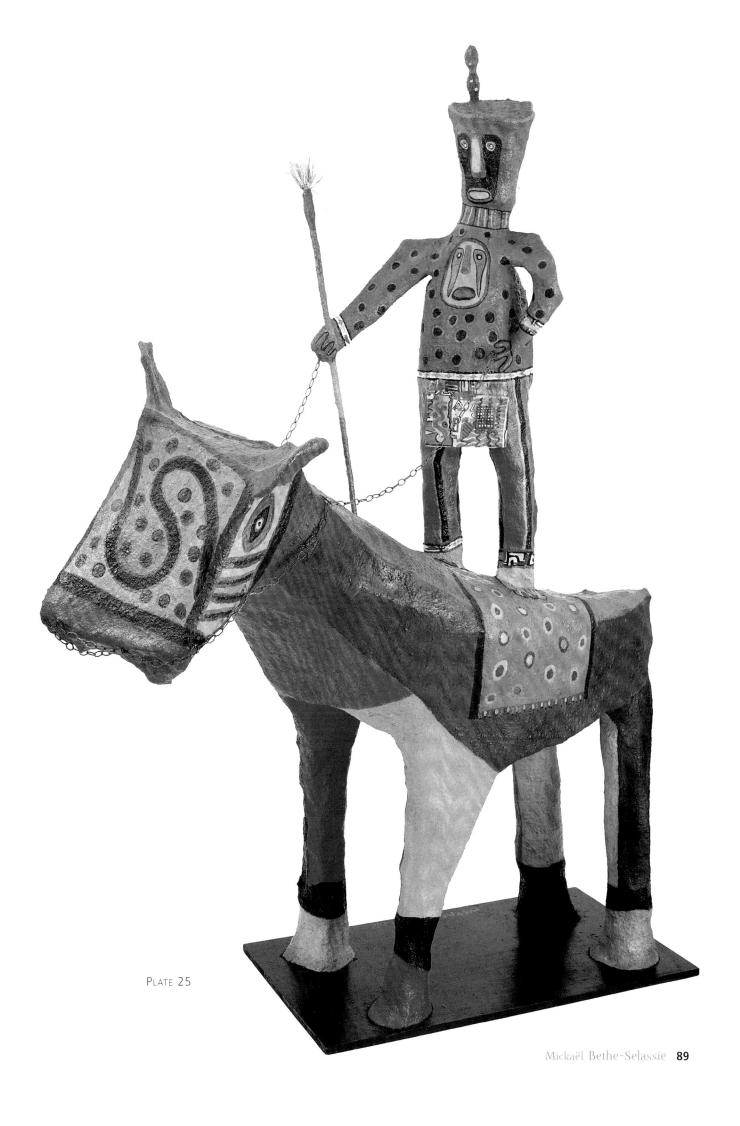

PLATE 25

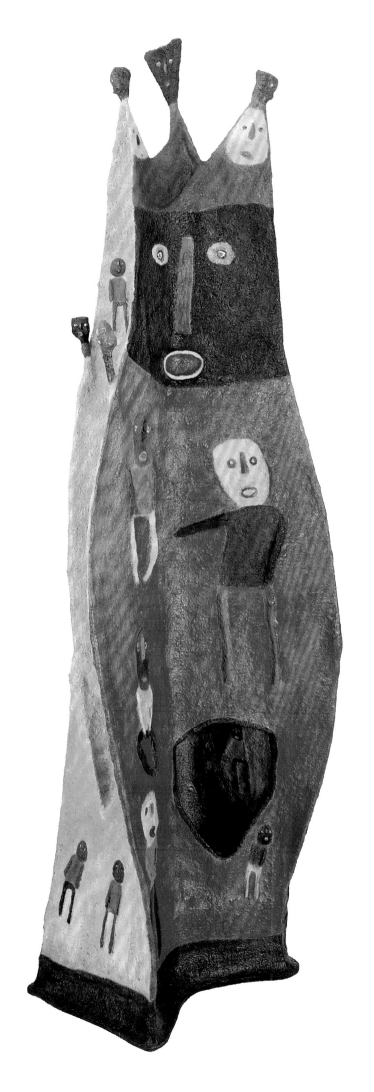

PLATE 26

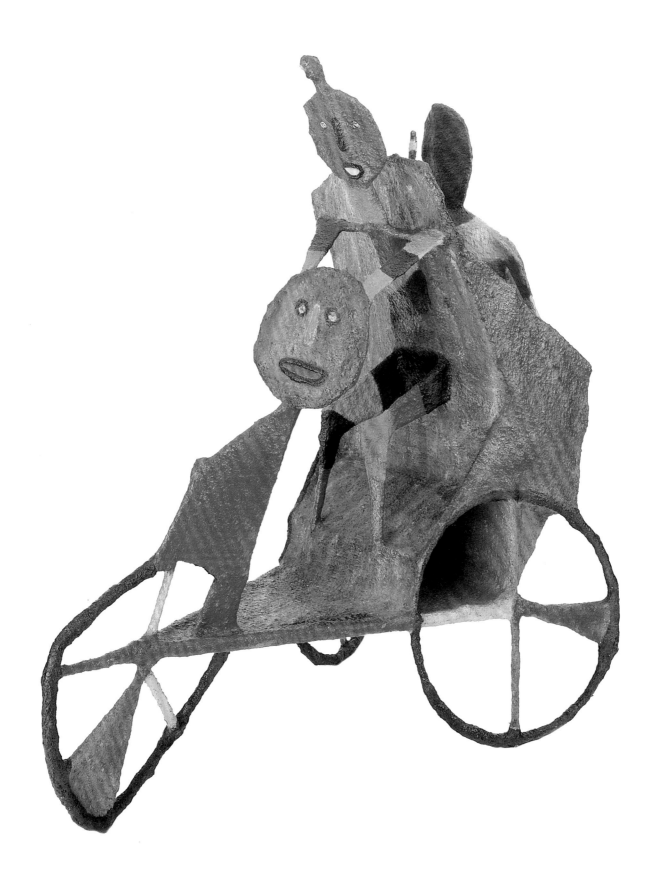

PLATE 27

Achamyeleh Debela
b. 1949, Ethiopia

The son of an amateur artist, Achamyeleh was born in Addis Ababa, Ethiopia. In 1967, Achamyeleh graduated from the School of Fine Arts, Addis Ababa, and completed additional training at the Ahmadu Bello University in Zaria, Nigeria, in 1972. A few years later, he relocated to Baltimore, Maryland, where he earned masters degrees from Morgan State University and the Maryland Institute College of Art, and completed a doctoral degree in computer graphics and art education at Ohio State University. Achamyeleh currently teaches at North Carolina Central University where he is director of the Computing Center for the Arts, and recently spent a year as a Fulbright scholar in Ghana and Ethiopia.

The artist considers color as "Form and object, it is the rhythm and perspective . . . it is spiritual and personal and at the same time it is universal." Achamyeleh's complex digital images are rooted in the artist's interests in technology, his examinations of cultural heritage and his understandings of conventional media. Achamyeleh's works are continuously changing and evolving, and the digital medium allows him to revisit and re-manipulate images.

PLATE 28
Scarification II
1991
Digital image cibachrome print
48 x 66 cm (19 x 26 in.)
Collection of the artist; courtesy
Contemporary African Art Gallery,
New York

PLATE 29
Song for Africa
No date
Digital image cibachrome print
100 x 74.5 cm (39 x 29 in.)
Collection of the artist; courtesy
Contemporary African Art Gallery,
New York

PLATE 30
Spirit at the Door
1992
Digital image cibachrome print
68.5 x 48 cm (27 x 19 in.)
Collection of the artist; courtesy
Contemporary African Art Gallery,
New York

Plate 28

PLATE 29

Plate 30

Elizabeth Habte Wold

"Coming to Howard and being introduced to African-American culture, artists and interacting with talented art, music and theater students in the College of Fine Arts was perhaps the most significant event of my life; there was always a sharing of ideas among the students. My experience in the USA broadened my horizon. It has been an experience that helped me to maintain balance and perspective."

Interview with Carol Dyson, October 2002

Wosene Kosrof

"Howard was . . . like home in another place. Howard gave me the means to analyze and understand myself as an Ethiopian, an African and a citizen of the world. Howard also fully supported my day-to-day activity. My painting studio instructor and thesis advisor pushed me to go farther and farther . . . to experiment . . . to find a new direction and to give expression to my expanded vision. He urged me to 'go back home in your mind,' to bring something new. He mentioned Ethiopian writing as a possible reference point or content in my MFA thesis work and that became the bedrock for the whole thing . . . research and development of the past 25 years."

Interview with Carol Dyson, October 2002

Kebedech Tekleab

"At Howard, I was exposed to American culture and that introduced me specifically to the art of African Americans . . . the historical aspect of it, the social, economic and political situations of the whole country. It was at Howard that I came to know Native American cultures . . . I started painting about my understanding and appreciation of the culture. Not only was Howard central to my understanding of the art world, but Howard helped me in self-discovery, racial and ethnic identification and a sense of place in a world context."

Interview with Carol Dyson, October 2002

Howard University, Ethiopia and Ethiopianism

Jeff Donaldson

The word *ethiopia*, meaning "land of the sun-burned, or black-skinned people," represented a sense of place and identification for Africans who, as American slaves, became land lost, renamed and denied the use of their native tongues. On another level, Ethiopia the independent, ancient and powerful African empire—biblical Ethiopia, with its power and prestige was a source of hope and redemption throughout the centuries of slavery.

Thus, even before emancipation, the concept of ethiopianism came to be associated with pride, independence, self-motivation and reliance. Ethiopianists were those who believed that "Africans, themselves, on the political level, are thoroughly competent to chart their own course of development and to manage their own affairs"[1] and, regarding religious practice, the forces are latent within Africa itself "to redeem" it.[2]

One such ethiopianist was the scholar-activist William Leo Hansberry (1884–1965) who established four courses in African art history at Howard University as early as 1922. Later (1929) he proposed a Varia Africana, i.e., a full-fledged, degree-granting program in African studies, as:

> *No institution is more obligated . . . No Negro . . . school is in a better position to develop such a program as Howard . . . ; No institution has access to more specialized libraries . . . , Nowhere else are the thought and planning put forth; No better courses exist anywhere . . . There are no better trained students anywhere . . . This is an area in which Howard has the most promising and immediate opportunity to distinguish itself as a leader in the general cause of public enlightenment.*[3]

Hansberry asserted that his Varia Africana would revolutionize stereotypical misconceptions about African peoples and cultures. His overarching objective, however, was nothing less than a multifaceted, comprehensive program to develop a leadership cadre equipped with knowledge of their history and armed with the ability to manage contemporary world affairs, and ultimately, "to arouse [African] peoples . . . to make a specific effort to revive and develop to the full those creative and spiritual powers, which are nature's pre-eminent gifts to the African."[4]

For reasons unknown, the Howard University administration rejected the Varia Africana proposal. Hansberry was undaunted. He redoubled his broad sympathy for all things African and continued to excel in his own area of scholarly inquiry—ancient and medieval Ethiopian history. Indeed, over a 40-year career, he was internationally recognized as one of the leading authorities in the field.

While maintaining his commitment to teaching and research, Hansberry made time to provide effective leadership to several organizations and initiatives in the worldwide resistance movement against Italy's invasion of Ethiopia, coordinating activities with affiliates in Africa, Europe and the Americas.

At the same time, he sought out potential leaders among his students, encouraging them to support Ethiopian sovereignty and promote the ethiopianist ethic, both here and abroad. To this end, Hansberry began a long association with Howard's first Ethiopian enrollee, 1929 medical school student Malaku Bayen, cousin, page and attendant to Crown Prince Ras Tafari, and later "His Majesty's [Haile Selassie's] Special Envoy to the Western Hemisphere." Under Hansberry's leadership, Malaku Bayen and Ralph Bunche (Howard University political scientist and future Nobel Laureate) among others founded the Ethiopian Research Council (ERC) in 1924 "to disseminate information on the history, civilization and diplomatic relations of Ethiopia in ancient and modern times," but, due to "certain recent international developments," (i.e., the imminent Italian invasion of Ethiopia) the ERC would "for the moment, concern itself primarily with the task of assembling and disseminating information about contemporary Ethiopian affairs."[5]

Italy invaded Ethiopia in 1935 and ERC members assisted the Ethiopian war effort on several fronts. Hansberry determined overall policy for the ERC. Bunche was an advisor on international affairs. Malaku Bayen was an effective fundraiser for Ethiopia's fight against Italy and took a leadership role in convincing many professional African and Caribbean Americans to volunteer to go to Ethiopia and assist in that country's overall development and to combat fascism.

In 1937, Malaku Bayen and Tuskegee-trained Chicagoan John Robinson[6] organized the Ethiopian World Federation (EWF) "to fight for the interests of black people everywhere." The EWF and its official organ, the Voice of Ethiopia (VOE), played a significant role in the development of black and African consciousness and unity, especially in the United States. Proclaiming "we are out to create a United States of Africa," Malaku Bayen, as executive director of the EWF and editor of the VOE, with his U.S.-born wife, Dorothy (longtime Howard University budget officer), as EWF secretary and VOE business manager, led in the creation of 27 EWF chapters with branches in the U.S., the Caribbean, Central and South America.

In August 1936, James V. Herring, founding chairperson of the Howard University art department (1925), an ERC member, accompanied Dr. Arnold Donowa, president of the Medical Committee for the Defense of Ethiopia (MEDCOM), a major African-American fundraiser for Ethiopia, to the U.S. State Department in an unsuccessful attempt to obtain visas for a "competent Ethiopian national to come" to the U.S. for "lecturing" on and "clarifying" the Ethiopian situation. Apparently, the State Department viewed their petition as a ploy to secure visas for a delegation that might include the emperor and under pressure

from the Italian government and Italian-American special interest groups in this country, the MEDCOM request was denied.

Despite similar rebuffs from U.S. agencies and government officials, the ERC, EWF, MEDCOM and other pro-Ethiopian organizations contributed significantly to the Ethiopian war effort and its overall development, and Howard University—faculty, staff and students—played major roles in that success. For his part, Hansberry was awarded the First African Research Award by the Haile Selassie I Prize Trust in 1964.[7]

A few years later Skunder Boghossian, one of the artists in this exhibition with Howard University connections, received the Haile Selassie I Prize Trust for National Contributions to the Field of Art in 1967. Skunder taught at Howard University from 1972 until retiring in 2001, and his presence encouraged an enduring institutional framework that has fostered the development of several generations of young artists, and continues to do so. In an interview at Howard University in December 2002, three members of the university's creative community drew on their own memories and perceptions to discuss the Howard legacy and diaspora in more depth.

ENDNOTES

1 St. Clair Drake, *The Redemption of Africa and Black Religion* (Chicago, Ill.: Third World Press, 1970), 71.
2 Ibid. "Forces" here refers to the burgeoning autonomous African Christian Church movement of West Africa in the late 19th century.
3 Joseph E. Harris*, Pillars in Ethiopian History* (Washington, D.C.: Howard University Press, 1974), 20–22.
4 Ibid., 12.
5 Joseph E. Harris, *African-American Reactions to War in Ethiopia, 1936–1941* (Baton Rouge, La.: Louisiana State University Press, 1994), 20.
6 Robinson, "The Brown Condor," became head of the Ethiopian Air Force in 1944 and was one of the two African-American pilots known to have seen combat in the Italo-Ethiopian War of 1936–41.
7 Harris, *Pillars in Ethiopian History*, 26–27

Ethiopian Diaspora and the Visual Arts: A Discussion

A discussion conducted on December 3, 2002, by Elizabeth Harney (**EH**) and Kinsey Katchka (**KK**) with members of the faculty from Howard University.

MEMBERS OF THE HOWARD UNIVERSITY FACULTY

Floyd Coleman (FC), professor of art, has written and lectured widely on African-American art.

Jeff Donaldson (JD), dean of the College of Fine Arts and professor of art emeritus, has been instrumental in the black arts movement since the 1960s, especially as founder of the organization AfriCobra, an influential Chicago-based black artist collective.

Abiyi Ford (AF), filmmaker, scholar and professor of film studies, grew up in Addis Ababa, where his mother ran a successful local theater and taught music.

EH The exhibition *Ethiopian Passages: Dialogues in the Diaspora* is designed to show the works of artists working across the media, across generations and across genders. It will represent a broad mix of visual approaches and histories. The museum's interest in Ethiopian modern arts dates to its second director, Sylvia Williams, who had a close and long-standing personal and professional relationship with Skunder Boghossian.

Before her untimely death, she had been exploring the possibilities of mounting a retrospective. The project never materialized. It had only just begun to scratch the surface of the story of artistic practice in the Ethiopian diaspora. It soon became clear that a rich story

Kebedech Tekleab and Alexander "Skunder" Boghossian
Nexus (detail)
2001
Aluminium mounted on granite wall
365 x 1585 cm (144 x 624 in.)
Embassy of Ethiopia, Washington, D.C.

Mounted on the Wall of Representation at the Embassy of Ethiopia in Washington, D.C., this collaborative work highlights the intergenerational links among the artists within the diaspora community. The aluminium relief sculpture incorporates decorative motifs, patterns and symbols adapted from diverse Ethiopian religious traditions and forms that represent musical instruments, utilitarian tools and regional flora and fauna. Together, these designs compose a sense of Ethiopian identity and are intended as a balanced juxtaposition of traditional and contemporary Ethiopian aesthetics.

could be told based not only on Skunder's works but also upon those of others who found themselves in a widening diaspora. Some were his students, others just admirers or colleagues. Still others were part of a later migration or generation.

The aim of our discussion today is to talk about the relationship between the experiences of some of these diaspora artists and the Howard University community. Six of the 10 artists in the exhibition have studied at Howard at one time or another; not all, of course, directly with Skunder Boghossian. I'd like to get a sense of the institutional approach and framework at Howard to the long-standing presence of Ethiopians and other Africans here.

JD There is a history certainly that goes back to the 1920s with William Leo Hansberry, Malaku Bayen and Ralph Bunche and with James V. Herring, who was the founding chairman of the College of Fine Arts. They were all active in the 1930s in drumming up support for Ethiopia during the Italo-Ethiopian war. So there was a history there. Malaku Bayen may have been the first Ethiopian student to ever come to Howard [in 1929]. Hansberry was very important in raising the consciousness here, not just about Ethiopia, while that was his area of specialization, but Africa in general. And that has been a characteristic at this institution long before Skunder or any of us came here. James A. Porter[1], for example, visited Ethiopia in the 1960s and started to collect work by Afewerk Tekle for the Howard University Gallery of Fine Art.

FC I think that Jeff has given us a wonderful summary of the early years and that has continued into the next generations. Dr. Joseph Harris has written a wonderful book[2] that deals with the African-American perception of the Italo-Ethiopian war—that legacy with Ethiopia has continued and we have other Africanists on the faculty who are doing very important work on all parts of Africa.

You mentioned Skunder, and whatever contribution I can make will have to center around him because I became aware of contemporary African art through my association with Skunder, prior to my coming to Howard. It was in Atlanta in the late 1960s and I met Skunder when he first came to this country. I happened to see him at the Atlanta University annual exhibition. And then, later on, when he moved to Atlanta to work at the Center for Black Art, that's when I got to know him. What amazed me about him was his ability to take anything and just completely transform it. We did an ill-fated mural but it was fantastic what Skunder did.

Skunder's work pulled from all of Africa. You could see that he was conversant with the forms whether they were from Côte d'Ivoire or Zaire [now the Democratic Republic of the Congo] or whatever. You could see those residues . . . in his work. For me, he is the quintessential artist of Ethiopia and of contemporary Africa, certainly of the last 40 years or so. I happened to be in Birmingham this last week and saw Karen Weaver's mural in the airport and I just thought about Skunder when I saw it—those powerful forms, those rhythms and so forth. Skunder's influence is so great, and I know I was greatly influenced by him—not so much directly, I didn't try to emulate him but something of his sense of energy and motion and movement and his sense of line helped transform what I was

doing and so I really see contemporary art through the lens of the art of Skunder Boghossian. If you look at some of the artists who have studied here at Howard you can see the influence there.

AF Let me just add a few points. I grew up with Skunder. I knew his family quite well and I hung out with him. They have given you a good background sketch from the art point of view, but I think a little more of the history is important. The presence of Howard as a premier institution through which you could access the intellectual wealth of the African-American community, anyone outside of Africa who wished to have some kind of interface with that body of knowledge clearly was focused in this direction. That's a magnetism that Howard has. That's why people like Skunder Boghossian found comfort in coming here.

And I think that Skunder, even beyond being a highly gifted painter, has another dimension: his ability to use the smallest number of words to communicate to students. His paintings terminate in the frame, but outside of that, the way he influenced others was very critical: the way he talked, the way he explained things, the way he saw the metaphorical elements in Ethiopia, and so on.

But I think that on another level the people like Joe Harris had Ethiopia as a focus for a number of reasons. One, it was the senior [independent African] state for quite awhile . . . and was governing itself, and even my father was much impressed with that idea. The idea here was that to access Africa you had to go through and absorb it unencumbered and, hence, the importance of Ethiopia.[3]

Howard probably has the largest collection of religious artifacts from Ethiopia, housed in the School of Religion. You have the materials and collections here from when Haile Selassie received his honorary degree and Howard was a convenient and politically solid referential point in the halls of power in Ethiopia, whenever they wanted to touch the ear of the African American. Haile Selassie was very much aware of it. We knew about Howard.

There was a tremendous tug of war with the Europeans in Ethiopia. Before the Italian invasion and afterwards, the Ethiopians were walking around with a sense of confidence because their reference point of ethiopianity versus European was the victory at Adwa.[4] So that was sometimes interpreted as arrogance by Europeans.

The State Department . . . was concerned with preventing at all costs the possibility of the conjunction of Ethiopian arrogance with the anger of the Negro—they felt that that would be a very bad cocktail. The anger of the Negro was being organized and structured along the Garvey movement. So they did not want these two pieces to come together.

EH Did the U.S. government claim to support the Haile Selassie monarchy?

AF Well, it appeared that they supported the Ethiopians but, in fact, Ethiopia was a pawn and served a purpose. It provided the Americans with a base [they could use] after the Second World War. For the Americans . . . the enemy was not the Germans, they had been defeated; now colonialism was the enemy. They wanted to dismantle that. If they were to gain their independence by still being colonial then it would go against two strikes—one, the

advocacy of democracy, the Americans would say, and two, America would be much smaller and isolated in that sense, so the Americans championed the dismantlement of colonialism. So it's true that the Americans did help to dislodge the British who were sticking their claws deeper and deeper into Ethiopia.

JD But they wanted to replace the British not liberate the Ethiopians!

AF Right, nobody was trying to liberate anyone. They were marriages made of convenience. So in that sense yes, the State Department was a champion in support of Haile Selassie . . . And of course this is why they assisted him in becoming more central and [sent representatives to] Ethiopia, and he [Haile Selassie] was also a very good symbol because of his stance at the League of Nations. But all the while it was known that internally they'd had a lot of difficulties in Ethiopia, so it was not liberation of the Ethiopians per se, but of the maintenance of Haile Selassie as a figure.

Also, this effectively put a wedge between the African-American community and the Ethiopians, because when the African Americans went there to render their services, they would be there on their own allegiance and commitment. When the white Americans came, they had a government behind them. They had lots of materials. So on these grounds the story in theory back home was "Do we want to mess around with these blacks? They come in here and look for jobs. The other guy, he brings jeeps, and he brings this and that . . ." a major, clearly distinct campaign.

Also, they spread rumors through the Greek and Armenian communities about the "N" word—*Negro*—and so we all grew up not wanting to have anything to do with "Negroes." Ethiopians were really recruited into that. The images we (as Ethiopians) saw of African Americans were negative images, so we didn't want to associate with that. [5]

But the music was always attractive. Sports were always attractive. . . . In the academic community, Harvard, Yale, Columbia . . . they'd even try to buy us, discourage people from coming to Howard, but they'd get a different orientation here; more Afro-centric than at the Ivy League schools. . . . But in terms of reputation, they were obviously much higher. So that was a big problem back home: where do you want to go to school. Howard? Those who knew, understood. Those that didn't . . .

But coming back to art here—people like Kebedech[6] were aware of Howard as a concept and wanted to be affiliated with that concept. She made a clear beeline for Howard. As a consequence, her activities have benefited from her affiliation with the community of students and scholars here. There were other opportunities [for her to go to school] but she felt she could get what she needed best from here. Howard's history and Skunder drew her here.

EH Do you think that by the time she got here there was a broader sense by a younger generation that this was a supportive community, with Skunder and then others around him?

AF Exactly. You see when you speak about the arts and painters, you've got two names. Afewerk Tekle and Skunder Boghossian.

JD And Gebre Kristos Desta. Three.

AF But they're really pushing these two. Skunder was known. So wherever he is, others will end up.

Of course there's another element here, which is the role that I played. I was at Columbia, and I didn't know much about Howard. I was getting further and further away from my own reality; so when I was offered a job at Howard, I wound up coming here and realized that there was a whole new universe that I had to address. I had to learn a whole new conceptual vocabulary, a whole new reference in which to teach. I had to disengage from models of the West and shift to another model to find out more about myself, more about Africa, more about African Americans. And that led me to come here where I was the founding chair of the department. And I brought in Haile Gerima (well-known Ethiopian contemporary filmmaker).

EH One of the aspects we hope to emphasize in the exhibition is the diversity of the artists who passed through Howard. Aida and Kebedech both have a connection in some way to Skunder, and yet it's not a visible one. When you talk about how he taught, did his teaching create Skunder spin-offs, or did it create a whole variety of artists who were interesting and creative in their own ways? Is there a lineage at work here? Aida says she admires the works of Skunder and Wosene but she doesn't feel that they have influenced her works. How does one begin to define a diaspora without confining people within it, because these artists are not working within one particular aesthetic or agenda?

FC One of the points I was trying to make earlier. While in Atlanta, he [Skunder] didn't have the actual [African diaspora] works, but there were those images, and he just transformed them in his unique way. So if you really look at certain of the works from, I'd say, the early 1970s, and on, you'll see . . .

There is another part of the equation that we've got to deal with, and that is Jeff's influence in transforming the art department here at Howard. Moving away from a Eurocentric perspective to one that encompassed Africa and African-American history and culture.

JD Skunder was a key element in that transformation, but it had started before he arrived here. He fit right into what we were doing.

FC There were also those from Ghana, Ethiopia . . .

JD The Caribbean, from West Africa, Central Africa, East Africa, like never before.

FC And women.

JD In all those areas, never before had that happened in fine arts. So all of these things were brought to bear on Skunder as well as on us. And Skunder influenced all of us, and we

influenced him. I would say that perhaps Wilfredo Lam[7] was one individual all of us respected. Skunder met him at a conference of Negro writers and artists in Rome (1959). We had met him through our own individual research as scholars who were trying to find our roots, and when we couldn't find them in institutions, we found them in the work of people like Lam. Lam was forced to leave Europe ahead of Hitler.[8] And he left all his work because he and Picasso shared a studio.

I would think that Skunder was central to what we were trying to accomplish, but we were also central to his development, to what came to be the greatest body of work that he created here. And like Abiyi pointed out beautifully, Skunder had established himself as an international artist of the first rank even prior to coming to this country. [He had been collected] in New York, at the Museum of Modern Art, and in Paris, prior to his coming to the U.S. So he had established himself, but he was still growing and developing . . . and that movement, that convergence of the black arts movement, the black studies movement, and the civil rights movement, that convergence took place in areas all across the States. All these things together resulted in a fusion of ideas, of talents and of energies that led to what we now call Trans-African art. It was a visual art, but more concerned with what undergirded it, because we gave it a new meaning in the work that we produced.

There were three or four students here who did work directly with him, but they couldn't get beyond the long shadow he cast. On the other hand, there were people like Wosene Kosrof, Aida Muluneh and Elisabeth Atnafu, who was a student in the Howard University School of Journalism and transferred to the College of Fine Arts before Skunder came here. She never studied with Skunder but later worked with him, gaining much that she could never have gotten from the classroom. As a matter of fact, if she had gotten it from the classroom, she would never have had the independence she has had. Because they met as equals and exchanged ideas. And he was able to tell her things that she was too young to know when she left Ethiopia. She didn't leave because of the Derg.[9] She left because her family was here. Elizabeth Wold's family was here. Kebedech Tekleab's family was here.

I think that the important thing to note is that the Ethiopians did not segregate themselves here, and [try to form a] clique; Skunder did not address himself to the Ethiopian students one way and to the African-American students in another way. I think in this institution, there's a greater integration of native-born Africans and diaspora-born Africans than at any other institution in this country. And that has to do with the fact that there has been that long-standing relationship, a special kind of relationship between Africa, through people like Leo Hansberry[10] and Ralph Bunche[11] and with that part of the world. And Ethiopia, you know, figures very prominently in our history as a concept, as a nation, and as Abiyi pointed out, it is the part of Africa that we identify with because that was the part that was independent. That was the part that was free. That was the part that accepted Christianity before the Romans put Holy in front of the Holy Roman Empire. That Christianity pre-dated Western Christianity and justified Christianity as a religion for black people. And that came through Ethiopia because Matthew, one of the apostles, had ties to Ethiopia.

So that our acceptance of Christianity came as a consequence of that knowledge that Ethiopia was the seat of our understanding of Christianity. And our acceptance of that could

never have come otherwise. And up until the beginning of [the 20th] century most black people identified themselves as Ethiopian, and not as African; not as Negro or colored. White people wouldn't use the term, but to others the greatest complement you could give a person was you're Ethiopian.

AF But Ethiopians . . . there's another peculiarity about Ethiopians in the diaspora, and that is that they tend to flock. In any field, if an Ethiopian gets notoriety there will be two types of flockers or followers. One, genuine artists; the others, sort of copiers. And they are generally very much short of the essence and comprehension of what the others have. They'll give you a headache.

There's also an assumption made by the weaker of these—when I say weaker, in the sense of maturity. These individuals assume that they already know their cultures and those of Africa. They assume that Howard is not up to their par and that they're doing Howard an honor to come here. I've had these debates and discussions where people use all the flowery language of this and that, and my rule in the classroom is . . . who are you and where do you go, what's your referential point, etc. There's a lot of struggling going on in the Ethiopian community as to who is good, who is not good. So there need to be distinctions made.

The second thing is happening in Ethiopia today. All the agencies, like Alliance Française, are getting extremely active in supporting the arts. My sister,[12] for example, sells a lot of her paintings, and you would not expect that. She started out as a sculptress and now she paints. But because she made a lot of money and was able to build her own house, there are others who say, " . . . she did it, I can too." So it's going to get hard for you people in the art field to separate the wheat from the chaff, you know. It's going to be hard. And you'll get bit. You'll get jumped on . . .

EH This planning process has been a highly politicized experience up to this point. So take someone like Julie Mehretu who is a young artist based in New York who [has one parent who is Ethiopian, the other is American] . . . She grew up partly in Addis Ababa, partly in Dakar and partly in East Lansing, Michigan. It was a real mix. And now she's getting a lot of press in the New York art scene and just completed a residency at the Walker Art Center. She has a very interesting way of thinking about herself in relation to being in an Ethiopian diaspora show, and its very nice to hear this very broad sense of identity in relation to her work, which does not look in any way connected to traditional Ethiopian art or even anything drawing from Skunder. But when I mentioned that she was in the show, some community insiders said, "Well, she's not really Ethiopian. She shouldn't really be in this show."

It's a really wonderful exercise to feel that you're able to complicate the notion of diaspora and identity in relation to these aesthetics.

FC It's the quantum nature of the diaspora . . . if the individual says they're from Ethiopia and they're working from that point of view. That's about as far as you want to go (unless you get into DNA). Conceptually, that's what is important.

KK Do you have an ongoing communication and exchange with the School of Fine Arts in Addis Ababa, for example, in what's going on there now?

AF As a matter of fact, we are in the process of pushing a linkage between Addis Ababa University and Howard University. One linkage is with the fine arts, because now Addis Ababa University has taken over the art school. And the School of Music. They're [taking] a little bit of time integrating into the academic world there because they're two independent spirits. So, we're trying to see if sending a team over from here will help them streamline into the "academic world," and indicate to both sides that there is no threat in them coming together.

KK One thing we touched on earlier while talking about Skunder was the fine arts program. As professors, how do you see your program as cultivating the training of Ethiopian artists, and what do you do to engage students and help them integrate into the community?

FC I think [that] students—whether they're Ethiopian or Nigerian, or South Carolinians—[should be introduced] to the arts of the African diaspora and certainly a lot of the students that come to Howard have not done any extensive work and have not had any exposure to African-American art. They don't realize its long history. That's one of the things that all of these students are required to do—at least two courses—the African-American art survey and then of course we have African art, the spectrum going from Egyptian to contemporary. And we're doing more interdisciplinary kinds of things, more visual culture. So for the first time, I think some of these students will see that wider black world and begin to understand where they fit in that world.

AF I'm not in art, my field is film and cinema. What I usually do is I push more analytical thinking so that the product . . . comes . . . from solid thinking instead of just copying.

KK One of the other things that has been so interesting in putting together this show is how diverse the media are in terms of what these generations of artists are working in, and this is maybe a reflection of how your art department has developed, working across the media. Is there a generational shift, would you say, from painting to other media?

AF I'll have to go back to Skunder. Skunder, whether he was doing three-dimensional things or two dimensional, had that kind of ability to express his vision no matter what [the medium] was. So he's not bound to painting at all. I think there are a lot of students—of course, this is part of the African tradition—there's . . . what Lévi-Strauss calls the *bricoleur*, the idea of being able to take all these disparate things . . .

JD This is something that we developed here, too. The notion of breaking down barriers, not just between plastic expression but all forms of artistic expression, is European.

FC Right.

JD We don't conceive of music without dance, or dance without visual art in the African tradition. We've developed a whole curriculum around the notion of what we call experimental studio; where a student doesn't have to make a declaration "I'm a painter, I'm a whatever." They can go through the whole curriculum without making any declarations. They can do anything and everything they want to do.

KK And yet the film program is separate.

AF Yes, it is separate, in large part because we are budgetarily cost intensive. If we were in fine arts, we'd be dead because of the budget [this] has. Because we're part of communications, we're part of a new agenda and we can get the money to buy the cameras and all that. And we're still short.

But we're about to have a committee look at how we can fuse, maybe come together at the faculty level to do some experimental work with faculty in fine arts and with us.

FC The whole idea of the so-called New Media really just makes the idea of working in all of these areas possible, at least virtually, and I think that certainly our students are doing this. And it really takes them back to what Jeff just said about the African tradition. This new technology is facilitating that.

KK Perhaps we can close on the question of diaspora—if we look at the artists in this exhibition, how might we characterize diaspora?

FC I don't think it's cohesive in the sense of a movement. I think that [they all look] at it in different ways. You're not going to get a monolith, but something that is very fluid with certain shared concepts.

With respect to the concept of diaspora, that's always shifting and changing. And as a concept, just the idea of movement, moving out, moving through and so on, it's a term that's most efficacious in light of what has taken place over the last 500 years. When you use a term, you just have to realize that it is not something that is clearly defined, clearly delineated.

EH Yes, one scholar of diaspora has suggested: "It should not be an explanatory term, but exploratory."

AF I submit that there is such a thing as an Ethiopian diaspora, because certain fundamental elements are present. Here you have the Ethiopian churches. The food is here. The marketplaces are here. A community is woven around that. This community is not well integrated as a whole; you have different groups of Ethiopians that came. You have the first wave, which was royalists who fled the Derg. The second wave would be those who chased the royalists. They fled and came here too. Then you have the remnants of the Derg, they came here—so all three groups came here. But they don't like each other.

EH Do the politics of home cast a shadow in the diaspora?

AF Yes, and it's a battleground for all kinds of things. You have the three groups along political lines. Then we have the [different ethnicities] Oromo, Amhara, the Eritreans and the Tigrayans. And then you have the Christians and the Muslims.

Most of the icons are Christian—and that's why I think the piece (*Nexus*) that Skunder and Kebedech did [at the embassy] is really a major, major work, in terms of representation. It carries all the iconic symbols that are representative of different groups, cultures, and religions. This is one of [Skunder's] strengths. Some others, also very good painters, have been restricted to predominantly Christian symbols and that's problematic, it's controversial.

KK Earlier you mentioned that, historically, there has been a wedge between the Ethiopian and African-American communities in Ethiopia. Does this happen in the United States as well?

AF I'm glad you asked that. It is alive and well. That wedge exists. The chasm between the host African-American community and the Ethiopian diaspora is vast. Certainly you can't say that it's innate or genetic; its information. So there is out there a discourse that's operating that convinces or sways the Ethiopian who comes here into tending to think of himself as different than the African American. People like Skunder and Kebedech, they're way past that—but not the community in general.

That's a consequence of this dominant discourse that says Ethiopia is in Africa but not of Africa. Ethiopians are not quite African, they're not semitic . . . Ethiopians have had a civilization where the others did not. This differing, this kind of discourse and rhetoric—a lot of people fall into that and talk in terms of "we're politically different" from the others, which is a sad state of affairs. It's beginning to crumble a little bit now. But here, you still have that. We still have that.

ENDNOTES

1 James A. Porter (1905–1970), a prominent scholar focusing on African-American art history, authored *Modern Negro Art*, the first comprehensive history of African-American art. In addition, he was an influential teacher at Howard University for over 40 years and an acclaimed artist.

2 *African-American Reactions to War in Ethiopia 1936–1941* (Baton Rouge: Louisiana State University Press, 1994).

3 That is, to understand Africa, it was necessary to look at a state such as Ethiopia, which had not experienced colonialism as had the majority of African states.

4 The Battle of Adwa took place in 1896. Ethiopian forces under Emperor Menelik II united to defeat the Italians. The battle and the victory were particularly important because they caused other European powers to recognize the sovereignty of Ethiopia on the world stage.

5 In a communication following the interview, Ford clarifies that "Rumors and negative demeaning stereotypes of African-Americans (Negroes) were circulated among the white residents of Addis Ababa (Armenians, Greeks, Italians, English) whenever they came in contact with white Americans. Ethiopians were referred to as non-Negro people. Exempt from the negative pejorative 'Negro,' elite Ethiopians joined the chorus in the use of 'Negro' as a demeaning term. To be called a 'Negro' in Addis Ababa in those days was tantamount to being insulted" (Ford 2002, personal communication).

6 Kebedech Tekleab, an Ethiopian-born artist and former student of the Addis Ababa School of Fine Arts, attended Howard beginning in 1990, receiving her BFA (1992) and MFA (1995).

7 Cuban artist Wilfredo Lam (1902–1982) spent much of his life in Europe. In his work, he created his own style fusing surrealism and cubism with the spirit and forms of his Caribbean heritage, and has influenced many artists of African descent.

8 Lam fled occupied France in 1941, returning to his native Cuba.

9 Provisional military administration extablished in Ethiopia following Haile Selassie's deposition in 1974. It officially continued through 1987 when the Ethiopian republic was declared.

10 William Leo Hansberry (1894–1965), an Africanist historian and anthropologist, joined the faculty of Howard University in 1922. There, he taught courses on African civilization, history and archeology—an effort that met, at first, with much dissent from other Howard University faculty. Hansberry lectured, taught and conducted research throughout Africa during his career. In 1963, as a distinguished visiting professor in Nigeria, he attended the inauguration of the Hansberry College of African Studies at Howard University.

11 Ralph Bunche (1904–1971), statesman, scholar and founder of the National Negro Congress, was a champion of civil liberties both at home and abroad. An important international figure, the long-time Howard University professor participated in the preliminary planning sessions of the United Nations. In 1948 he negotiated the peace agreement between Egypt and Israel for which he was awarded the Nobel Peace Prize.

12 Bisrat Shibabaw, a painter and art instructor at the Addis Ababa School of Fine Arts.

Then and Now:
The Arts in Addis Ababa

Achamyeleh Debela

As in all other cities, Addis Ababa has its own uniqueness and beauty. This is not about a city full of skyscrapers and luxury hotels and glamorous shops like Western cities, though it has some of those too. Rather, the beauty of Addis Ababa is embodied in its distinct landscape composed of sloping hills, large and small churches decorated with beautiful mural paintings and well-paved modern roads interspersed with potholed ones. These days Addis Ababa can boast of a ring road that circles its peripheries and connects all the small and large communities. Since the time of Menelik—emperor of Ethiopia in the late 19th century—it has functioned as the political, economic and social nerve center of Ethiopia. This is a city that has attracted Ethiopians from all walks of life and has grown through multiple migrations and exoduses. When I grew up there in the 1960s, it had seven hundred thousand people rather than the two million it has now.

This was the vibrant city I knew as a child. Unbeknownst to me, it was also home to a fine arts school that would become an important site for the practices of the country's most prolific modern artists.

The Early Art Scene

Painter Agegnehou Engida was among the few foreign-educated artists who lived and practiced in Addis Ababa in the 1930s. He was an accomplished artist who studied at the Ecole des Beaux Arts in Paris from 1926 to 1933. He, and a number of lesser-known artists, received generous government patronage. Agegnehou was responsible for mural paintings in the Parliament buildings (completed 1934) and those in the Sellasé church, the largest in Addis Ababa.[1] A modest self-portrait is also held in the collection of the National Museum in Addis Ababa. He was primarily a portraitist, with a talent for handling realism. His treatment of facial expressions shows a sensitive and introspective analysis. He also designed several drawings that were used as part of the Ethiopian dollar and other currency, certificates and stamps.

Unlike the Ethiopian clergy artists whose patrons consisted of the church, the nobility and royal family, modern artists like Agegnehou found a new clientele that included foreign dignitaries, expatriates, tourists and a growing intellectual bourgeoisie composed of the often

foreign-educated sons and daughters of nobility with a taste for the modern. Ageynehou remained faithful to his academic training and applied it to traditional Ethiopian subject matter. The modernist trend that was vibrant in experiments of various "-isms" in Europe, where the few returnees studied and practiced at the time, did not affect artists who insisted on academic conventions. While they did not establish a formal school, each took under their wings a few apprentices who were later to practice independently and receive acclaim in their own right. These small but important beginnings set the stage for the creation of the Addis Ababa School of Fine Arts in 1957.

In the late 1950s and early 1960s, Africa underwent significant political and social developments. Many nations were throwing off the yoke of colonialism, and the newly independent nations were building their state infrastructures. Art played a major role as a symbol of nationhood and the new dreams and aspirations of independence. Artists were called upon to research and illustrate these ideas from a well of rich visual heritage, both local and pan-African. Several pan-Africanist artists were on the forefront in the creation and celebration of the independence of their nation. In the context of Ethiopia, painter and sculptor Afewerk Tekle made a significant contribution with his famous stained glass window titled *The Struggle and Aspiration of the African People.*

Haile Selassie's government sent Afewerk to study art in England in 1947 where he graduated from the Slade School of Fine Art, University of London. While some of his pieces tend to be carefully and deliberately geometric, by and large, he uses a realistic approach with a tendency to elongate his figures for expressive purposes. The latter style is well illustrated in the *The Spirit of the Dance* and in his sculptural designs, such as the monumental statue of the late Emperor Haile Selassie's father, Ras Makonnen in Harar. Several smaller pieces are found at Studio Alpha, a renowned residence/studio that the artist designed based upon the historic architectural structures in Gondar. Afewerk has served as cultural advisor in one capacity or another to the monarchist government of Emperor Haile Selassie, the Marxist regime of Mengistu Haile Mariam and the current government of the Ethiopian People's Revolutionary Democratic Front (EPRDF) under Meles Zenawi. Through his work and engagement in the pan-African movement, Afewerk elevated the status of the modern artist.

The Addis Ababa School of Fine Arts (1957–2000) and School of Fine Arts and Design, Addis Ababa University (2000–present)

The birth of the Addis Ababa School of Fine Arts is closely linked with the modernist painter and educator Ale Felege Selam. Artist Ale Felege was born in 1929 and taught himself how to draw and paint. In 1949 he received a scholarship from the Ministry of Education and became the first Ethiopian to study art in the United States. Ale Felege completed his studies at the Art Institute of Chicago and returned home in 1954. He came with the aspiration of teaching and encouraging young Ethiopians. Although there was no art school, he began teaching students whom he recruited from area high schools. His art classes were conducted

in the old Ras Imiru compound where he had rented a house. As he watched his students' progress, he dreamed of developing a full-fledged art school program. To this end, he launched a fundraising campaign for which he organized an exhibition of works by his students and invited the members of the royal family, diplomats from the various embassies and friends.

After several shows, Ale Felege had raised significant funds. He appealed to Emperor Haile Selassie for help in realizing his dream. The emperor authorized funds for the building and ordered the Ministry of Education to cooperate in the process. In 1957, the Addis Ababa School of Fine Arts (fig. 22) opened with Ale Felege Selam as its first director.

Although the school was now a reality, securing faculty was another problem. There were no Ethiopian artists trained to teach in the art school setting. In an attempt to fill the faculty positions, Ale Felege went to the foreign embassies for assistance. As a result the first expatriate faculty members included Austrian sculptor Herbert Seiler, who taught anatomy, figure drawing and sculpture, and Vincenco Fumo, an Italian painter who had initially come to Ethiopia as a soldier under Mussolini. There was also Madame Gutenberg, a German who taught art history, the German graphic artist Karl Heinz Hansen (also known as Hansen Bahia),[2] who taught printmaking, and the late Ethiopian painter and calligrapher Yigazu Bisrat. Yigazu, who was working for the Ministry of Education as an illustrator at the time, was asked to transfer to the School of Fine Arts. He had not studied art abroad, but was one of the few who studied under the early pioneers of modernism, the sculptor Abebe Woldegiorgis and painter Agegnehou Engida, as an apprentice.

The founding of the School of Fine Arts in 1957 ushered in a new era. As Ethiopian artists who were trained abroad began to return, more opportunities were created to hire faculty. In 1962 Gebre Kristos Desta returned from West Germany where he had studied art at the Art Academy in Cologne (fig. 23). In 1966 Skunder Boghossian returned from France where he studied and practiced briefly at St. Martin's and the Slade School of Fine Art in

FIG. 22
School of Fine Arts in Addis Ababa

Fig. 23
Gebre Kristos Desta
Bar Scene at Ras Hotel
1961
India ink and acrylic
on paper
22.8 x 30.5 cm (9 x 12 in.)
Ras Hotel, Addis Ababa

London, England, and at the Ecole Nationale Supérieure des Beaux Arts and the Académie de la Grande Chaumière in Paris. Abdul Rahmin Sharif, whose own work focused on collage, began teaching at the school in 1968.[3] Zerihun Yetmgeta started working at the school in the late 1960s, while Worku Goshu joined the staff in 1973. All these artists infused a new creative energy in the school, and through their own work significantly contributed to the cultural renewal taking place in Addis Ababa.

The primary objective of the Addis Ababa School of Fine Arts was to train art teachers to teach at the elementary and secondary levels. Another objective was to produce professional artists who could choose to specialize in commercial graphics or freelance as painters or sculptors. School of Fine Arts students engaged in a five-year course of study, then graduated with a diploma. The foundation years emphasized fundamentals in drawing, painting and sculpture. Additional courses included perspective, watercolor and oil paint techniques, anatomy, figure drawing and landscape, as well as a few courses in the history of Western art. There were also occasional courses taught by Peace Corps volunteers, diplomats' wives and other assorted expatriates. These studies focused on realistic rendering through observation.

In the fourth year, students began to experiment and study more intensely under the guidance of a particular faculty member. This was especially true in the final year, when each student was expected to produce a major work. In most cases, this took the form of an outdoor sculpture or a mural. For those who chose to emphasize graphics as their major, they were expected to produce a portfolio.

The Addis Ababa School of Fine Arts began to produce artists of high caliber. A number of those went on to study abroad, while others stayed at home and began to work in the school system or joined the government ministries or private sector. As the number of Ethiopian artists increased, so did the make up of the faculty. But for all intents and purposes, the curriculum remained the same until the rise of the socialist regime of Mengistu Haile Mariam in 1974.

In 1974 students, workers and soldiers began a series of strikes and demonstrations that culminated with the deposition of Emperor Haile Selassie by members of the armed forces. A provisional governing council, the Derg, was established to run the country, and in late 1974 it issued a program calling for the establishment of a state-controlled socialist economy. In March 1975 the monarchy was abolished, and Ethiopia became a republic.

In the years that followed, Mengistu emerged as the country's chief political figure. His position was consolidated in 1977 when several top leaders of the Derg were killed. Mengistu's regime continued to be strongly opposed by students, several political factions, and two secessionist movements in the Ogaden region of southwestern Ethiopia and in Eritrea.

The Ethiopian government subsequently received large-scale military aid from communist allies. Though international support enabled the government to make gains against the rebels, resistance to official authority continued. Meanwhile, a government program to reduce poverty and boost economic growth was stalled by recurrent drought and consequent famine, and sociopolitical upheaval was exacerbated by widespread famine. In September 1984, Ethiopia became a Communist state with Mengistu as its leader.

The Ethiopian government remained unstable and in 1991 the Ethiopian People's Revolutionary Democratic Front captured Addis Ababa, forcing Mengistu to flee the country. Since then, long-standing border disputes have continued to cause political unrest.

The "Socialist" Assault on Ethiopian Artists

Seventeen years of dictatorship had a significant impact on the development of the School of Fine Arts. The curriculum was changed and the course of study was shortened from five years to four, with the first two years for foundation courses and the third and fourth year for specialization. The new curriculum emphasized subjects that had potential for political propaganda such as graphics and mural painting. Students were put under pressures that led to fear and psychological distress. Those who managed to get out of the country stayed away, preferring exile. Those who remained in the country had to make the best of the situation.

Prior to the revolution, there existed an association of Ethiopian artists, though very little is known of its activities except for its role in organizing occasional exhibitions. At its establishment, the association's mission was to contribute to the development of the arts in Ethiopia, but its impact was limited.

However, in the heyday of the revolution, the association was reorganized with a newly revised constitution and by-laws. The newly organized Ethiopian Artists Organization was a

child of the revolution and its leadership came with credentials that included a membership card to the Socialist Party of Ethiopia. Its role, therefore, was closely associated with the principles and rules that governed the party and its cultural policy. It is not surprising, then, that additional training at the Yekatit 66 political school was expected for those who were recruited as artists for the party.

The Addis Ababa School of Fine Arts building had been built 45 years earlier and was deteriorating from neglect. During the Derg era, the conditions under which both faculty and students operated was partly dictated by the newly created Ministry of Culture and Sports, which was entrusted with the task of constructing a socialist culture in Ethiopia. In its August 1997 publication this ministry proclaimed its objectives:

. . . to arrange for the organization and promotion of culture and the arts in accordance with the principles of socialism and to encourage the creative power of the masses in the fine arts.
(Ministry of Culture and Sports 1997)

This ministry supervised music, painting, theater, cinema and literary creations. Persons who were appointed to enforce the declared objectives made life difficult for those artists who did not produce according to the dictates of the new standards a nightmare, while those who managed to do an occasional poster and painted murals when called upon, survived.

The cultural revolution required that classes be interrupted or halted due to sudden state visits or official government celebrations. The development of Prop-Art or slogan art was highly praised. Students were transported along with some faculty to where they were asked to paint huge canvases to be hung in front of prominent buildings. When the works of students and the art faculty were deemed unsatisfactory, artists were brought from North Korea or other communist countries and they produced huge posters of figures with Korean features in Ethiopian garb. Many monumental sculptures were made by friendly fellow socialist countries depicting Mengistu and other aspects of the revolution whose themes were co-authored and packaged by both the host regime and the Derg. All commissioned pieces were made according to the principles and guidelines of the governing party's policy. Some Ethiopian sculptors were asked to travel to Korea to assist as consultants on the characteristic features of Ethiopian peoples and on the designs of national and regional costumes. Most of these works became strange hybrids of Koreans in Ethiopian costume.

At the same time, Ethiopian artists who had already gained international acclaim were severely criticized. One pamphlet prepared for international consumption proclaimed that,

. . . pre-Revolutionary art exhibitions included works of high artistic quality, executed according to the latest international standard techniques. However, our famous artists of the past had little or no sense of "artistic responsibility" to society. None of them played a role of edification or tried to improve the unjust conditions of the oppressed masses. Realist or abstract, they all painted either for psychic gratification or for the local or international market. Ethiopian painting was an elitist art that was aimed at the rich

feudal-bourgeois magnets, diplomatic or international circles, the wealthy tourists and in a few cases, the stock markets of the advanced capitalist world.[4]

Such rhetoric characterized the psychological and political attack aimed at some of the prominent artists whose work did not conform to revolutionary principles of artistic and creative value. All scholarship roads led to the Eastern bloc countries, and art was meant to propagate and glorify the revolution. Those who did not support the revolution had to feign conformity; those who refused to participate were shunned and harassed. Every image they created was a target for criticism. The imprisonment of Ale Felege Selam and the flight of a number of artists to other countries were unprecedented. Gebre Kristos Desta was forced to leave the country in search of greater freedom.

The Addis Art Scene of the Millennium

The tumultuous political environment of the late 20th century shaped the current circumstances in which contemporary artists work in Addis Ababa. Having passed through the difficult years of the Mengistu regime, which was overthrown in 1991, a new generation of young artists has shown resilience, creative energy and potential that bodes well for a new chapter in contemporary Ethiopian art. The art scene of the new millennium strongly reflects both local and global influences with diverse perception and stimuli. Changes of attitude towards the role of arts in society and the creative freedom of individuals are evident despite various social, political and economic constraints and continued corruption that is presently strangling the country.

Perhaps a major change can be seen in the formation of new artists' groups in the early 1990s. In the absence of the National Artists Association, which disappeared after the demise of the socialist regime, younger artists began to come together to devise ways to keep the art scene alive. Among the early organizations whose activities have had impact were Friendship of Women Artists (FOWA), The Point Group and Awtar Group.[5] Groups such as these are making their impact by staging exhibitions and public forums in order to publicize the works of their members. Audiences vary, but the majority attending the Addis Ababa art openings seems to be from the younger generation, between 18 and 30 years of age. This is an encouraging trend for the future.

The art buying public's demography also seems to be changing. More Ethiopians are purchasing works at exhibitions and galleries. Small but impressive private collections are also developing, marking a substantive change from the past when most of the works were purchased by visitors, diplomats and foreigners, a trend that also resulted in the removal of the majority of the works being produced from the country.

The vibrancy of the art scene in Addis Ababa has greatly benefited from the recent return from exile in Germany of a seasoned painter, Yohannes Gedamu (fig. 24). Apart from exhibiting his works, he has engaged the community in discussions of contemporary art and its importance in Ethiopia. Other artists who are actively engaged in exhibiting their works

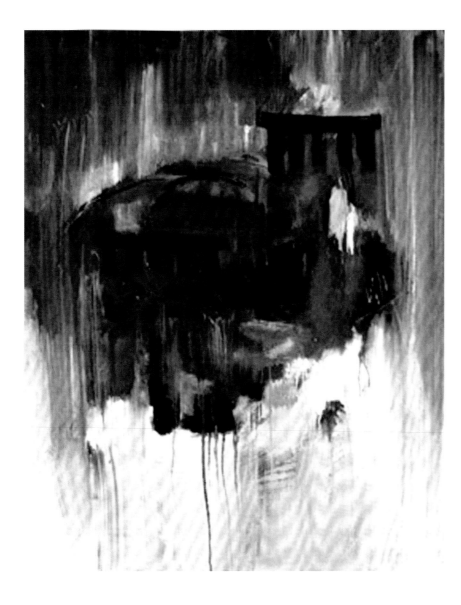

FIG. 24
Yohannes Gedamu
Untitled
2000
Oil on canvas
76 x 101.5 cm (30 x 40 in.)
Collection of the artist

both at home and abroad include Bekele Mekonnen (fig. 25), Leoulseged Reta, Behailu Bezabih and Fikru G/Mariam.

The change to the Addis Ababa art scene does not come easily. Professional and private galleries were the missing link in the Addis Ababa art scene of the past. A few pioneering individuals have opened private galleries. The first private gallery (1963–74) in Addis Ababa was the Belvedere. It was a combination of a framing business, a collection of gold Axumite coins, icons and traditional hand and neck crosses, but it mainly engaged in the contemporary Ethiopian art business. Skunder Boghossian and Gebre Kristos Desta had more than one exhibition at the Belvedere. The younger generation at that time, including the late Enndale Haile Selassie, Zerihun Yetmgeta, Feleke Armide and Wosene Kosrof, also had shows there. For awhile, it was a commercially viable gallery whose clientele included wealthy foreign collectors.

Needless to say, the business of promoting the visual arts in Addis Ababa is a complex issue that requires an understanding of the local and global marketplace and art criticism.

Fig. 25
Bekele Mekonnen
Untitled
2002
Mixed media
122 x 91.5 x 30.5 cm (48 x 36 x 12 in.)
Collection of the artist

While there are attempts to have discussions around issues of arts education or the state of the contemporary art scene in Ethiopia at public forums such as the German Cultural Center, the promotion of the arts and artists of today remains elusive. The absence of a critic or art historian who could provide some guidance to the broader context is of grave concern, since the lack of critical dialogue can lead to derivative works and fads based on the notion of what sells and what looks "modern."

Presently there are several venues where the contemporary Ethiopian artist can exhibit his or her work, ranging from homes converted to studio spaces, to historic Addis residences converted into gallery spaces to newer buildings where souvenir trinkets and artworks are sold along with food and beverages. Under these conditions the concept of an art gallery is equated with a souvenir shop. To the audience and/or visitor who makes no distinction, it suggests that such a presentation is acceptable.

To add insult to injury, one observes at such presentations colored lights and Western music that tops the essence of the evening sales of art by young Ethiopian artists. The promotional methods being applied in this case are misinformed and misguided in a country where there is not a single outlet or shop that sells art materials and where artists rely on donations and occasional purchases while abroad exhibiting or visiting friends.

Nevertheless, in recent years one can see certain attempts to improve the promotional resources available to artists. For instance, in 2002 the ZOMA Contemporary Art Center planned a week-long activity program. The series of events began with exhibitions of works by young graduates of the School of Fine Arts whose practices demonstrate technical dexterity and creative energy. There were several exhibitions that were held in different parts of the city as part of a "happening" called Gizeawie, meaning "temporary," which took place November 6–9, 2002.[6]

The works displayed were creative, but seemed to lack direction and self-reflection. The exhibitions gathered together a disparate mix of styles, which overshadowed a few highly promising artists and artworks that would otherwise stand on their own. The young artists that I encountered suffered from an admitted lack of exposure to guided discourse about the workings of exhibitions and the art market. One may argue that this genuine but misguided approach could be corrected if promoters take their responsibility to support the arts more seriously.

Gizeawie, while an interesting and absorbing event, was a misplaced exercise that did not meet either historical or cultural standards. Its design was based on the precedent of Conceptual Art "happenings"[7] that took place in the United States of the 1960s. On a different but related note, another disturbing and surprising element of the arts scene in Addis Ababa today is the absence of a clearly distinct government license between an art gallery and a souvenir shop. As a result, we have souvenir shops established as galleries of art that do not make distinctions between art, a framed trinket or a bad copy.

Be that as it may, there are some galleries whose efforts to distinguish quality have made a difference in spite of the fact that they have a license to operate a souvenir shop. For example, Asni Gallery seems to represent a variety of groups and individual artists. It has also distinguished itself as concerned for children to whom it has opened a Saturday art class. According to its founder and proprietor, Konjit Seyum, "Asni Gallery has made an extra effort to give opportunities to the young and emerging artists."[8] On the other hand, St. George Interior Decorations & Art Gallery prefers to serve a select few. ArtSpace is the third gallery that is run by yet another entrepreneurial personality, Meskerem Assegued. This is a roving gallery with an address at the Sheraton Addis and elsewhere in town. It has taken the form of a promotional agency by bringing artifacts from around the world and creating mini-festivals/exhibitions that are usually designed under a theme. Meskerem has managed to bring artifacts from as far as India and parts of West Africa. In addition, she has traveled to the Ethiopian hinterland to collect Ethiopian folk art and artifacts that were later assembled and exhibited at the Sheraton Addis. ArtSpace provides solo exhibitions in a residency atmosphere in a crowded part of town so as to reach a wider, more diverse audience. Credit is due to the artists who keep creating in spite of the odds, to the galleries who are making progress, creating the space and the necessary atmosphere, and to those who support their efforts, in particular the various foreign cultural institutes who have made a difference even when there were no galleries. Addis has become alive with cultural events even when the economic forecast seems gloomy. There is a growing audience that goes to the openings of solo and group exhibitions, and given the present trend, this audience will continue to grow and support contemporary artists, galleries and the public at large.

What is missing is a reliable support system, whether public, private or government-sponsored, that can nurture the collection, preservation, promotion and development of contemporary art in Ethiopia. The National Museum is severely in need of a budget to maintain its existing collection. In its present condition it cannot adequately display its permanent exhibition, let alone attempt to organize thematic, changing exhibitions. The ongoing benign neglect of Ethiopian heritage results in serious damage to the well being of

national identity and pride. This particular sector is in dire need of attention. A concerted effort is needed to conserve deteriorating paintings, old and new alike. There is not a single organized body, private or public, that advocates for the creation of a National Gallery, an arts council or an equivalent to a National Endowment for the Arts. At present, any advocacy for providing leadership or training of future artists is focused on the School of Fine Arts and Design at Addis Ababa University.

The recent move to bring the school into the university has a new impact in the academic and artistic education of future graduates. Armed with a new curriculum and a well-organized departmental structure, a formidable leadership, as well as a determined faculty, the School of Fine Arts and Design can make a difference to the dynamics of change and progress. The support needed from all concerned sectors should therefore be channeled towards this historic institution of higher learning. Meanwhile, collaborative civic organizations should be formed to promote, protect, advance and channel cultural and creative energies of young and talented artists for a united future in a united Ethiopia.

ENDNOTES

1 Elisabeth Biasio, *The Hidden Reality: Three Contemporary Ethiopian Artists* (Zurich: Volkerkundemuseum der Universitat, 1989), 66.

2 Ibid., 84.

3 Ibid., 85.

4 Eshété Alémé, *The Cultural Situation in Socialist Ethiopia* (Paris: UNESCO, 1982), 27–28.

5 Awtar, from the Amharic word for "dimension," was organized for the sole purpose of putting together an annual exhibition of its members. Awtar organized public forums about the works and has made an effort to use the group exhibition as an occasion to identify emerging artists or artists who have made a significant contribution to the development of contemporary art in Ethiopia.

6 Among the Ethiopian artists included were Elisabeth Atnafu from New York and Mickaël Bethe-Selassié from Paris, both featured in *Ethiopian Passages: Dialogues in the Diaspora*.

7 Edmund Burke Feldman, *Varieties of Visual Experience: Art as Image and Idea*, 2nd edition (New York: Harry N. Abrams, 1972), 433. According to Feldman (1972), ". . . Happenings do not have a developed dramatic structure—that is, a beginning, a middle and an end; plot and character development; climax and denouncement. Happenings deliberately stress the transient nature of what man creates and anticipate the ultimate obsolescence of any work of art by causing themselves to disintegrate almost immediately as objects and events."

8 Konjit Seyum 2002, personal communication.

Museums, cultural institutes and art galleries in Addis Ababa

MUSEUMS

ADDIS ABABA MUSEUM
Meskel Square
Ras Biru Building
Tel: (251-1) 11-91-13 / 15-31-80
Fax: (251-1) 15-99-04

ENTOTO MARIAM CHURCH MUSEUM
Addis Ababa, Ethiopia
Tel: (251-1) 11-02-76 / 12-51-31

ETHIOPIAN STUDIES & CULTURAL HERITAGE
Addis Ababa, Ethiopia
Tel: (251-1) 15-76-30

ETHIOPIA POSTAL MUSEUM
P. O. Box 1629
Addis Ababa, Ethiopia
Tel: (251-1) 51-50-11

ETHIOPIAN TOURISM & HOTEL COMMISSION
PERMANENT EXHIBITION
P. O. Box 2183
Addis Ababa, Ethiopia
Tel: (251-1) 51-74-70 / 44-45-75

INSTITUTE OF ETHIOPIAN STUDIES
ETHNOGRAPHIC MUSEUM
Ras Makonnen Hall
Addis Ababa University
Addis Ababa, Ethiopia
Tel: (251-1) 11-94-69

MUSEUM OF NATIONAL HISTORY
Addis Ababa University
Science Building
Addis Ababa, Ethiopia
Tel: (251-1) 55-39-77

NATIONAL HERBARIUM
Addis Ababa University
P. O. Box 3434
Addis Ababa, Ethiopia
Tel: (251-1) 11-43-23

NATIONAL MUSEUM & ARCHAEOLOGICAL
INSTITUTE
P. O. Box 76
Addis Ababa, Ethiopia
Tel: (251-1) 11-71-50

ST. GEORGE CHURCH MUSEUM
P. O. Box 2208
Addis Ababa, Ethiopia
Tel: (251-1) 11-46-89

CULTURAL CENTERS / INSTITUTES

ALLIANCE ETHIO-FRANÇAISE
Tel: (251-1) 55-02-13

BRITISH COUNCIL
Tel: (251-1) 55-00-22

FRENCH CENTER FOR ETHIOPIAN STUDIES
Tel: (251-1) 56-23-53

INSTITUTE OF ETHIOPIAN STUDIES
ADDIS ABABA UNIVERSITY
Tel: (251-1)11-94-69

ITALIAN CULTURAL INSTITUTE
Tel: (251-1) 11-36-55

RUSSIAN CENTRE FOR SCIENCE AND CULTURE
Tel: (251-1) 55-13-43

SCHOOL OF FINE ARTS AND DESIGN
ADDIS ABABA UNIVERSITY
Tel: (251-1) 11-13-00

GALLERIES

ASNI GALLERY
Addis Ababa, Ethiopia
Tel: (251-1) 11-73-60 / (251-9) 20-66-97

CHILOTA STUDIO
Tel: (251-1) 53-33-29 / 71-24-43

GOSHU ART GALLERY
Wereda 17 Kebele 17
House 157
Addis Ababa, Ethiopia

JANET STUDIO
Tel: (251-9) 22-50-03 / 53-12-80

MENBER JOSEPH ART GALLERY
P. O. Box 40757
Tel: (251-1) 16-04-43

ST. GEORGE INTERIOR DECORATIONS
& ART GALLERY
P. O. Box 7096
Addis Ababa, Ethiopia
Tel: (251-1) 51-09-83
Telex: 21954

TIBEB GALLERY, MASTER FINE ARTS AND
VOCATIONAL TRAINING CENTER
Tel:(251-1) 11-60-56 or (251-9)
21-47-04 / (251-9) 21-41-77

Suggested Reading

African Art Today: Four Major Artists. African-American Institute, May 14–August 13, 1974. New York: African-American Institute, 1974.

African Artists in America. New York, N.Y.:The African-American Institute, 1977.

Athiopien in der volkstumlichen Malerei. Stuttgart: IFA Galerie, 1993. Stuttgart Institut für Auslandsbeziehungen, 1993.

Barkan, Elazar, and Marie-Denise Shelton, eds. *Borders, Exiles, Diasporas*. Stanford: Stanford University Press, 1998.

Beier, Ulli. *Contemporary Art in Africa*. New York: F. A. Praeger, 1968.

Biasio, Elisabeth. *The Hidden Reality: Three Contemporary Ethiopian Artists*. Zurich: Volkerkundemuseum der Universitat, 1989.

Biasio, Elisabeth. "The Burden of Women–Women Artists in Ethiopia," in *New Trends in Ethiopian Studies: Papers of the 12th International Conference of Ethiopian Studies*, New Brunswick: The Red Sea Press and Michigan State University, 1994, pp. 304–33.

Brown, Evelyn S. *Africa's Contemporary Art and Artists*. New York: The Harmon Foundation, 1966.

Chojnacki, Stanislaw. "Gebre Kristos Desta; Four Years Later," *Ethiopia Observer* 11, no. 3 (1968): 176–77.

Chojnacki, Stanislaw. "Gebre Kristos Desta: Impressions of His Recent Exhibition Foundation." *Ethiopia Observer* 14, no. 1 (1971): 10–24.

Clifford, James. *Routes: Travel and Translation in the Late 20th Century*. Cambridge, MA: Harvard University Press, 1997.

Deliss, Clementine, ed. *Seven Stories about Modern Art in Africa*. London: Whitechapel Gallery, 1995.

Deressa, Solomon. "Skunder in Context." *Ethiopian Bir* (January/February, 1997): 14–28.

Dermerson, Bamidele Agbasegbe. "Canvas and Computer Painting and Programming: Technology in the Art of Acha Debela," *International Review of African American Art* 10, no. 2 (1992).

Harris, Joseph E., ed. *Global Dimensions of the African Diaspora*. Washington D.C.: Howard University Press, 1995.

Hassan, Salah, ed. *Gendered Visions: The Art of Contemporary Women Artists*. Trenton, N.J.: Africa World Press, 1997.

Hassan, Salah, and Okwui Enwezor, eds. *New Visions: Recent Works by Six African Artists*. Eatonville, Florida: The Zora Neale Hurston Museum of Fine Arts and Ithaca, New York: Cornell University, 1995.

Kennedy, Jean. *New Currents, Ancient Rivers: Contemporary African Artists in a Generation of Change*. Washington, D.C.: Smithsonian Institution Press, 1992.

Matsuoka, Atsuko, and John Sorenson, eds. *Ghosts and Shadows: Construction of Identity and Community in an African Diaspora*. Toronto: University of Toronto Press, 2001.

Mickaël Bethe-Selassié: Sculptures. Chartres: Musée des Beaux-Arts, 1995.

Taye Tadesse. *Short Biographies of Some Ethiopian Artists*. Addis Ababa: Kuraz Publishing Agency, 1991.

Additional readings are available from internet sources. See specifically the National Museum of African Art Library, Smithsonian Institution website: http://www.sil.si.edu/SILPublications/ModernAfricanArt/maa-start.htm

Contributors

David Binkley is the chief curator at the National Museum of African Art, Smithsonian Institution. Binkley has conducted field research in the Democratic Republic of the Congo and published on the arts of the Kuba and Northern Kete peoples. His current research interests include colonial and post-colonial artistic traditions in central Africa and their interpretations in Western scientific and popular thought.

Achamyeleh Debela is director of the Computing Center for the Arts at North Carolina Central University. He began using digital technology in his artwork while working on his doctoral degree in computer graphics and art education at Ohio State University. An accomplished artist, Debela recently spent a year in Ghana and Ethiopia as a Fulbright scholar.

Jeff Donaldson is dean of the College of Fine Arts and professor of art emeritus at Howard University, Washington, D.C. His essay "Ten in Search of A Nation" is included in *Theories and Documents of Contemporary Art* (1996). An accomplished painter, Donaldson has participated in several exhibitions in the United States and abroad, including *Transatlantic Dialogue: Contemporary Art In and Out of Africa* at the National Museum of African Art (2000).

Elizabeth Harney is the first curator of modern and contemporary arts at the National Museum of African Art, Smithsonian Institution. She received her doctorate, as a Commonwealth Scholar, from the School of Oriental and African Studies, University of London. She is completing a book on early Senegalese modernism and Négritude, to be published by Duke University Press. In September 2003, Harney joins the University of Toronto as an assistant professor of contemporary arts in the Department of Art History.

Kinsey Katchka, curatorial research associate at the National Museum of African Art, Smithsonian Institution, received her doctorate in cultural anthropology and African studies from Indiana University. Katchka has conducted field research in Senegal, and her work focuses on cultural policy, exhibition practice and contemporary expressive culture in Francophone Africa.